IMAGES
of America

CHICAGO'S ENGLEWOOD
NEIGHBORHOOD

AT THE JUNCTION

D1127743

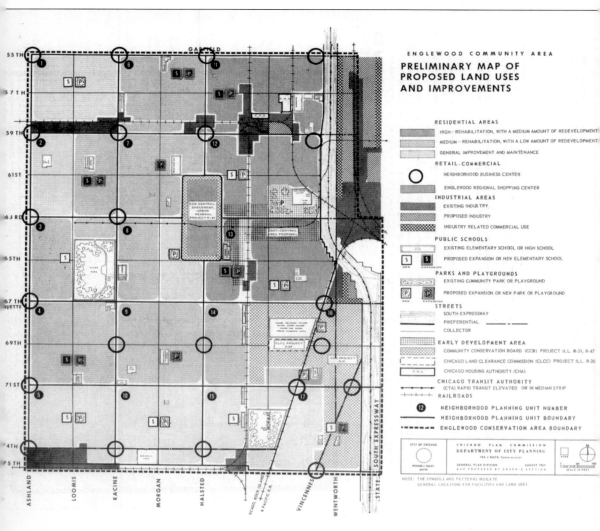

ENGLEWOOD COMMUNITY AREA

PRELIMINARY MAP OF PROPOSED LAND USES AND IMPROVEMENTS

RESIDENTIAL AREAS
- HIGH – REHABILITATION, WITH A MEDIUM AMOUNT OF REDEVELOPMENT
- MEDIUM – REHABILITATION, WITH A LOW AMOUNT OF REDEVELOPMENT
- GENERAL IMPROVEMENT AND MAINTENANCE

RETAIL-COMMERCIAL
- NEIGHBORHOOD BUSINESS CENTER
- ENGLEWOOD REGIONAL SHOPPING CENTER

INDUSTRIAL AREAS
- EXISTING INDUSTRY
- PROPOSED INDUSTRY
- INDUSTRY RELATED COMMERCIAL USE

PUBLIC SCHOOLS
- EXISTING ELEMENTARY SCHOOL OR HIGH SCHOOL
- PROPOSED EXPANSION OR NEW ELEMENTARY SCHOOL

PARKS AND PLAYGROUNDS
- EXISTING COMMUNITY PARK OR PLAYGROUND
- PROPOSED EXPANSION OR NEW PARK OR PLAYGROUND

STREETS
- SOUTH EXPRESSWAY
- PREFERENTIAL
- COLLECTOR

EARLY DEVELOPMENT AREA
- COMMUNITY CONSERVATION BOARD (CCB) PROJECT ILL. R-31, R-47
- CHICAGO LAND CLEARANCE COMMISSION (CLCC) PROJECT ILL. R-28
- CHICAGO HOUSING AUTHORITY (CHA)

CHICAGO TRANSIT AUTHORITY
- (CTA) RAPID TRANSIT ELEVATED OR IN MEDIAN STRIP
- RAILROADS
- NEIGHBORHOOD PLANNING UNIT NUMBER
- NEIGHBORHOOD PLANNING UNIT BOUNDARY
- ENGLEWOOD CONSERVATION AREA BOUNDARY

CITY OF CHICAGO — CHICAGO PLAN COMMISSION DEPARTMENT OF CITY PLANNING — IRA J. BACH, Commissioner — RICHARD J. DALEY, MAYOR — GENERAL PLAN DIVISION — AUGUST 1961 — MAP PREPARED BY GRAPHIC SECTION — ACRE — SCALE IN FEET

NOTE: THE SYMBOLS AND PATTERNS INDICATE GENERAL LOCATIONS FOR FACILITIES AND LAND USES.

GENERAL ENGLEWOOD PLAN, 1961.

The following is taken from the above map:

> The general plan sets forth in broad terms:
> 1. Degree and type of Urban Renewal needed.
> 2. Preferential Street Plan.
> 3. Community facilities recommended.
>
> The plan was developed by the Department of City Planning as its recommendation for the Englewood Community. Before it becomes the official plan for Englewood it is subject to review, change and approval by several official agencies or bodies. It is released at this time by the Department of City Planning as a progress report.

(Map courtesy of Englewood Business Men's Association.)

Cover Image: Anna Langford, Englewood alderman, 1971–1974 and 1983–1991, walks in the 1975 Easter Parade.

IMAGES
of America

CHICAGO'S ENGLEWOOD NEIGHBORHOOD

AT THE JUNCTION

Maria Lettiere Roberts and Richard Stamz

ARCADIA

Copyright © 2002 by Maria Lettiere Roberts and Richard Stamz.
ISBN 0-7385-2043-8

Published by Arcadia Publishing, ·
an imprint of Tempus Publishing, Inc.
3047 N. Lincoln Ave., Suite 410
Chicago, IL 60657

Printed in Great Britain.

Library of Congress Catalog Card Number: 2002112092

For all general information contact Arcadia Publishing at:
Telephone 843-853-2070
Fax 843-853-0044
E-Mail sales@arcadiapublishing.com

For customer service and orders:
Toll-Free 1-888-313-2665

Visit us on the internet at http://www.arcadiapublishing.com

CONTENTS

Acknowledgments 6

Introduction 7

1. Breaking Ground 9

2. Creating Community 23

3. The Business District 55

4. A Changing Neighborhood 87

5. Urban Renewal and Conservation 99

6. Contemporary Times 109

Selected Bibliography 127

ACKNOWLEDGMENTS

As we researched the history of Englewood, many people and organizations were eager to share their stories about life in the community. They gladly lent their services and photos to shape this book. Although not necessarily a comprehensive view, the sum of these images produces a rich history based on the development of the area. Pullman Bank and Trust was the first business to lend a hand, allowing us to use the photos archived by the original Chicago City Bank & Trust. Indeed, these images of the commercial district in the early days truly helped us to form the general history. The highly professional images ground the main commercial history in a way that no other archive comes close to. The current president of Pullman Bank, Daniel G. Watts, and his executive advisor, Ruby Larkin, generously gave of their time to the project. Pullman Bank and Trust Englewood Branch President Dee McGill and Assistant Branch Manager Joseph Miles also worked closely in obtaining the images used in this book. Additionally, Gavin Weir Sr., former president of the Chicago City Bank & Trust also lent images. Frances Kernis, wife of Norman Kernis of Norman Jewelers, her son, Jeffery Kernis, and Dr. Irving A. Kernis willingly gave of their time and materials to help shape the book. Without their efforts, stories, and insights, the book would not have the personalized aspect of a neighborhood tale. Audrey Drew, the director of the Englewood Business Men's Association, was also generous with materials and images and supplied us with detailed information regarding urban renewal plans and the commercial district mall. The Hirim Kelly Library in Englewood housed a helpful archive of images and materials related to the early days of Englewood's development. Today, this archive can be found at the Harold Washington Library Center, Special Collections and Preservation Division. The staff of the Special Collections Division—Morage Walsh, Glenn Humphreys, and Riva Pollard—were instrumental in helping to locate important photos and information for this book. The Chicago Historical Society's A.W. Mellon Director for Collections and Research Russell Lewis, and Robert Medina, played a crucial role by allowing the use of CHS's prominent collection to help support the storyline. Many individuals, remembering their families and homes in Englewood, encouraged us to write the book and gave stories of their family life including Carol Schuberth, Marcia Snider, Carol Abrams, James Stampley, and Henry Wilson.

Archie Motley, archivist emeritus at the Chicago Historical Society, helped us locate important information and gave us ideas about the historical value of the community and historian Ralph Pugh suggested information. Colleagues Astrid Lavie helped research information and Laura Kamedulski edited sections of the book. Tim Samuelson also helped to make the story livelier by steering us in different and unusual directions. Julia Sniderman Bachrach, of the Chicago Park District's Department of Planning and Development, was generous with her time and ideas and helped to produce a comprehensive representation of the parks in Englewood. Art and architecture historian Rolf Achilles also lent important images and suggested ideas. Phyllis Stamz, daughter of Richard, oversaw the development of the story line. Samantha Gleisten of Arcadia Publishing acted as editor for this book. Patrick Roberts initiated the idea, strongly encouraged us to write this history of Englewood, and offered sound advice, sources of information, and clear direction. The efforts of these individuals framed the history of Englewood in an exciting way, allowing us to remember the incredible history of Englewood, one of Chicago's most prominent South Side communities.

INTRODUCTION

Chicago's identity is generally embedded in two aspects that define the social and cultural context of the city: politics and neighborhoods. From these aspects stem the ethnic diversity and complexity of the urban metropolis. Englewood, located on Chicago's South Side, is a prime example of the way the personality of a neighborhood mingles with the politics of a city.

One could say that the story of Englewood is typical of the rise and decline of urban existence. Once home to a well-established middle-class population and the second largest commercial district in Chicago, Englewood is now one of the less economically advantaged neighborhoods in the city. However, digging deeper, the story of Englewood actually revolves around the community—its citizens and businesses and how they actively participate in the development and planning of the neighborhood. The stories of the individuals living there currently, and those who lived in the community in the past, remind us that Englewood was, and still is, a vibrant place.

This book paints the history of Englewood in broad strokes and does not intend to be a comprehensive survey of the region. Although told in chronological order, the history comes through the organizations, businesses, and individuals contributing to the book. They help to form the analysis of the history, thus allowing the book to be told from a more personal standpoint. The photographic collections come from a few sources that document Englewood in relation to their own businesses, associations, or lifestyle in the neighborhood.

The history of Englewood dates back to the mid 1840s. Much like the rest of the land, the area was flat and swampy. Native Americans inhabited the land, yet white settlers started moving in before the United States Government secured the rights. This contentious move was part of the overall ideology of developing land across the country. Railroads were built starting in the 1850s, bringing more lucrative and expansive trade to the area. Businesses, which were opened to serve settlers, travelers, and farmlands, spurted up in the area. These businesses opened in the area of 63rd and Halsted. The area was called Junction Grove, given the intersection of the railroads. In 1865, the Chicago Union Stockyards opened for business, with subsequent development in the surrounding areas.

As the community became more established, and businesses prospered, more middle class inhabitants started moving in. The area was far from the overcrowded urban conditions of the city and removed from the dirt and grime of the industry that developed in its center. Residents, wanting to procure a better social status, encouraged the establishment of better schools and social organizations. One of the biggest changes to the neighborhood came when the Cook County Normal School found its permanent home in Englewood in 1868. It was a premier training institution for teachers, developed at a time when the population was growing and the children were in need of more consistent learning. As elementary and high schools developed in the region, the location of the Normal School helped to foster what was considered an exemplary educational system.

In the same year that the Cook County Normal School opened, this portion of the Town of Lake changed its name to Englewood, a change promoted by the residents of the community, particularity Henry B. Lewis and his wife. To residents, the name was reminiscent of the legendary area in England, the Englewood Forest outside Carlisle, England. Mrs. Lewis

originally hailed from Englewood, New Jersey, which also had an influence on the name change. The area was wooded, thus symbolizing the relationship to these other areas.

Businesses proliferated as the community grew. In the 1850s and 1860s, the major businesses consisted of gardening and farming. A saloon was built at 63rd Street and Halsted. Others soon followed. Farmers south of the region often stopped in Englewood to do business and socialize as they brought their goods and produce to and from the stockyard area. During this time, people started building single-dwelling homes a bit to the east of 63rd and Halsted, thus prompting entrepreneurs to develop businesses. Property values skyrocketed in the 1870s and 1880s, with the largest growth to the commercial district occurring in the 80s. Although the central nerve of the commercial district was located at 63rd and Halsted, businesses fanned north to Garfield Boulevard (55th Street) and south to 71st Street. The area's heyday, however, came in the 20th century. Even during the Great Depression, the commercial district flourished.

After WWII, Englewood's ethnic makeup began to change. By the 1960s, Englewood had become a predominately African-American community; this shift in urban residency was occurring around the country as well. General patterns of migration into the suburbs and other areas allowed those already living in overcrowded communities to move in. Racial tension was part of the shift in demographics, however, those moving into Englewood were seeking homes and general neighborhood amenities as they too migrated to more appealing conditions. In the 1960s, Mayor Richard J. Daley promoted what was considered an innovative urban renewal plan to revitalize the major shopping center. Because Englewood had once been the second largest shopping district outside of downtown, the plan called for modernizing the district's viability and attributes, supposedly making it more appealing to shoppers. The plan, however, did not necessarily bring in large numbers of people, and revenue in the area continued to decline.

Currently, Englewood residents work to improve the community. Despite its years of decline, the residents work through community organizations, churches, and other types of grassroots associations such as the Boulevard Arts Center, for change. The city too is trying to improve and revitalize the community. Kennedy King College, one of the City Colleges, will change location and move into the main artery of the community, 63rd and Halsted. Changes such as these promise to bring new vitality to the community. Some residents have protested this change, yet, there is hope that this shift will bring prosperity to the neighborhood once more.

One
BREAKING GROUND

Before the turn of the century, Junction Grove, later Englewood, served an important function to Chicago. As a South Side hub in the Town of Lake, it connected Chicago to other parts of Illinois. It was not until around 1840 that the land was officially settled with the United States Government, though Native Americans and earlier pioneers had already started bringing prosperity to the area. As the government encouraged settlement, land speculators came to the Chicago area. Railroad transportation was one of the area's key assets with the Michigan, Southern, and Northern Indiana Railroad and the Rock Island Railroad creating a juncture around 63rd and LaSalle Streets. Farmers and small businesses serving the stockyards established the initial core community. Taverns and housing were constructed at will rather than as an organized settlement. Early settlers included Germans and Irish, who helped build the railroads, and later Swedish immigrants.

Englewood is a product of Chicago's industrial age, the years after 1848, that brought the railroads, centralized production, and the stockyards. Englewood, which began as a working class neighborhood, was fueled by the industry created and became a coveted middle class area as the city expanded and matured. The Great Chicago Fire of 1871, and the redevelopment that followed it, helped spur another wave of settlement, bringing many to Englewood. The area continued to grow in population, industry, and business, providing a fertile ground for middle class expansion. In 1889, the city, seeing how quickly the surrounding areas were growing, annexed approximately 125 square miles of land outside the city limits. Englewood, along with other major areas including Hyde Park, Pullman, Kenmore, and Lakeview, became part of the growing metropolis. Chicago's population increased to approximately one million overnight. This annexation allowed the residents of Englewood to reap the benefits of the city's municipality. Business, transportation, and institutions took root in the community, forming the framework of the thriving neighborhood.

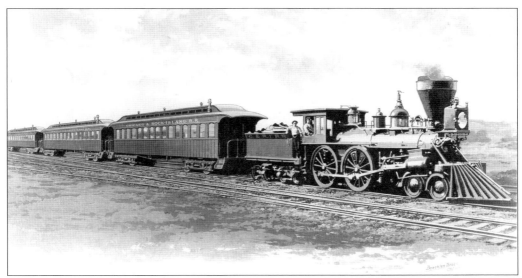

ORIGINAL ROCK ISLAND "ROCKET" TRAIN, 1852. This was one of the first trains for the Rock Island Railroad. Built in 1852, it ran from the west and crossed the Michigan Southern line at 63rd and LaSalle. (Photo courtesy of Pullman Bank and Trust.)

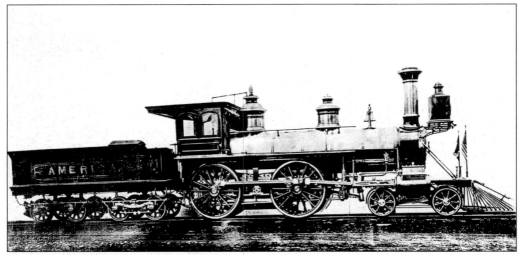

A ROCK ISLAND STEAM LOCOMOTIVE. The rail industry grew in Chicago, providing an important hub for transportation and goods throughout the United States. (Photo courtesy of Rock Island Lines, Special Collections and Preservation Division, Chicago Public Library.)

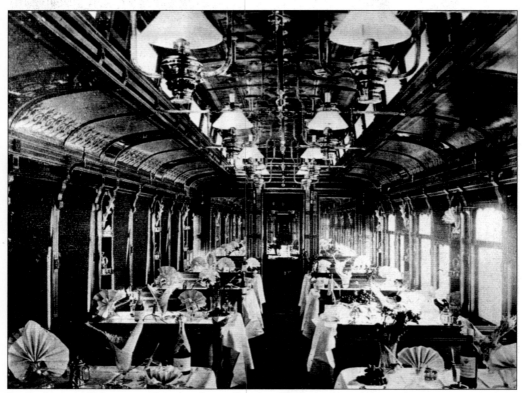

ROCK ISLAND RAILROAD DINING CAR. Comfortable lodging and amenities were essential for travel during the late-1800s. Tablecloths, proper place settings, and an ornamental design were key elements to middle and upper class patrons. (Photo courtesy of Rock Island Lines, Special Collections and Preservation Division, Chicago Public Library.)

HOUSE LOCATED AT **6438 S. HARVARD AVENUE, 1890.** This home was later demolished and replaced by an apartment building. As a single-dwelling unit, it highlights the influence of the middle class residents. (Photo courtesy of the Special Collections and Preservation Division, Chicago Public Library.)

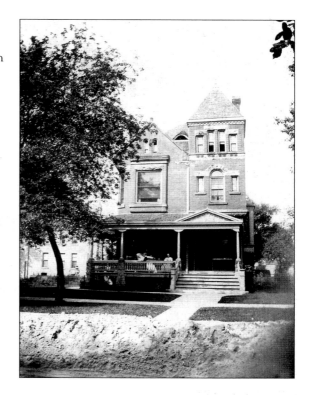

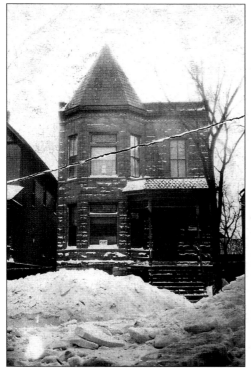

ENGLEWOOD HOUSE. Because of the Great Chicago Fire of 1871, three years later, in 1874, the city passed an ordinance decreeing that homes and buildings must be constructed with materials other than wood. It became fashionable to use brick not only to build, but as ornamentation. (Photo courtesy of the Special Collections and Preservation Division, Chicago Public Library.)

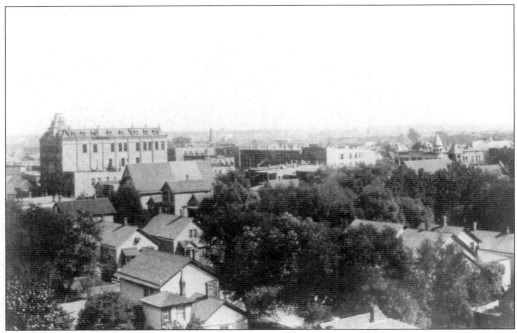

BIRD'S EYE VIEW OF ENGLEWOOD, 1889. This view of Englewood provides a sense of how expansive the infrastructure and community had become. The city government incorporated the outlying areas and their population so that Chicago would be regarded as a formidable place for the World's Columbian Exposition of 1893. With the anticipation of the World's Fair, Englewood experienced a building boom to fulfill the needs of the visitors. (Photo courtesy of the Special Collections and Preservation Division, Chicago Public Library.)

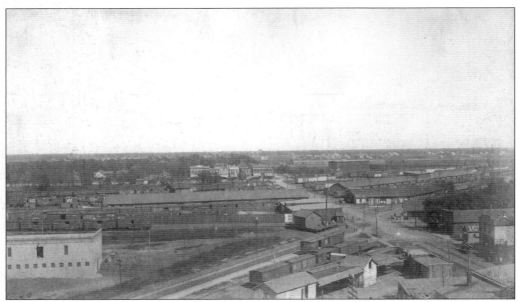

VIEW OF A RAILROAD CROSSING IN ENGLEWOOD, 1889. (Photo courtesy of the Special Collections and Preservation Division, Chicago Public Library.)

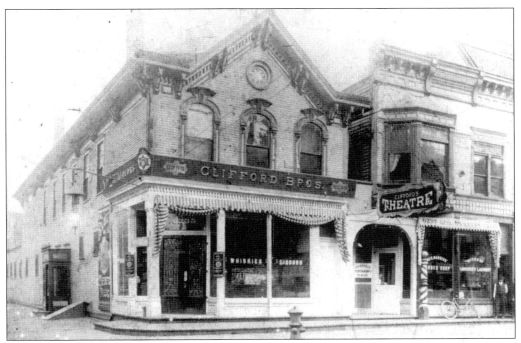

CLIFFORD BROS. STORE AND THEATRE, HALSTED STREET AND ENGLEWOOD AVENUE, 1896. Some businesses catered to variety, such as Clifford Bros. Store, which included a liquor store and theatre. This was later the site for the second location of the Chicago City Bank. (Photo courtesy of Pullman Bank and Trust.)

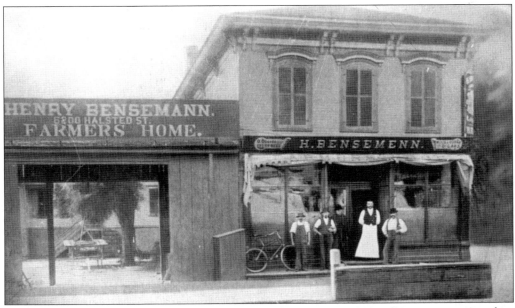

HENRY BENSEMANN STORE, 6200 S. HALSTED STREET, C. 1880S. Bensemann catered to farmers and provided a variety of products to the general population. (Photo courtesy of Pullman Bank and Trust.)

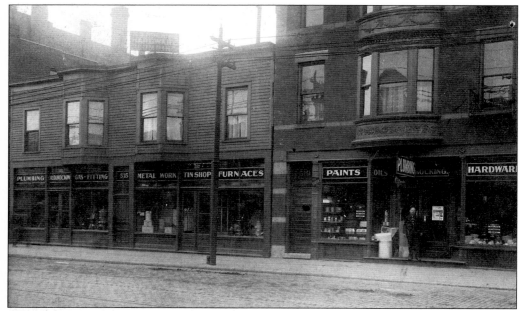

R.D. HOCKING HARDWARE, 1890s. The existence of hardware stores generally indicates a large amount of building and construction in any given area. Early businesses in Englewood catered to those developers, workers, and farmers in the surrounding area. (Photo courtesy of the Special Collections and Preservation Division, Chicago Public Library.)

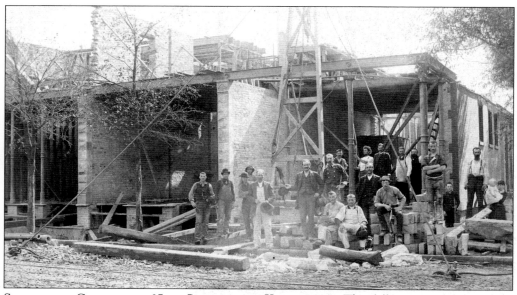

SOUTHEAST CORNER OF 65TH STREET AND YALE, 1897. The following individuals and companies constructed this building: E.W. Sproul was the mason; E.G. Petterson was the carpenter; Wells and Smith did the plumbing; and Orville M. Morris was architect and landscaper. (Photographed by Orville M. Morris, Landscape and Architectural Photographer, 3134 Vernon Avenue, Chicago. Photo courtesy of the Special Collections and Preservation Division, Chicago Public Library.)

DOUGLAS HALL BUILDING, 63RD STREET, WEST OF STEWART AVENUE, C. 1911. (Photo courtesy of the Chicago Historical Society, courtesy of Pullman Bank and Trust.)

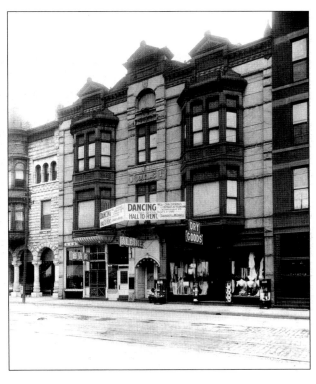

BARKEY'S STORE, ON 63RD STREET, 1890. (Photo courtesy of Pullman Bank and Trust.)

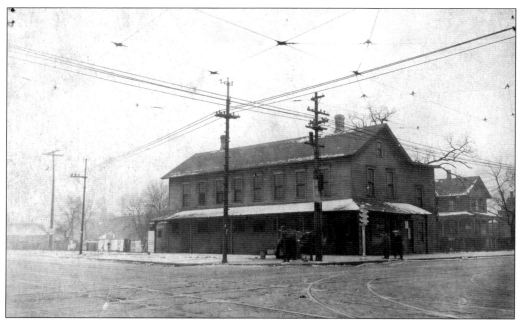

TEN MILE HOUSE, C. 1890S, LOCATED AT 79TH AND VINCENNES. Vincennes was a Native American trail before settlers moved in. The trail created a route for trade providing a location for a few scattered businesses to cater to the needs of tradesmen and pioneers. (Photo courtesy of the Special Collections and Preservation Division, Chicago Public Library.)

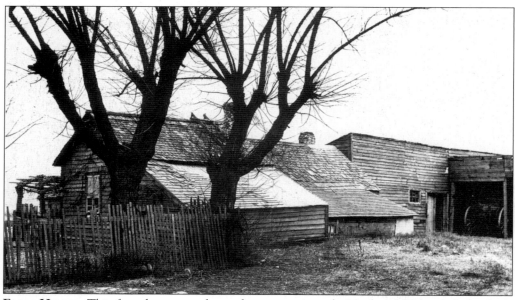

FARM HOUSE. This farm house was located at approximately 82nd and Halsted. Individuals who acquired farmland in the area just outside of Englewood were well connected to the physical and social development of Englewood. They lived in close proximity to the neighborhood and many purchased farmland before the community experienced its boom, thus participating in the area's growth. (Photo courtesy of the Chicago Historical Society.)

PORTER'S GARAGE, 64TH PLACE AND WENTWORTH, 1914. (Photo courtesy of the Special Collections and Preservation Division, Chicago Public Library.)

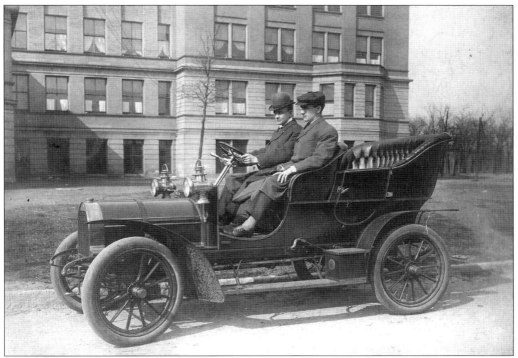

ONE OF THE FIRST AUTOMOBILES IN ENGLEWOOD. The car was owned by Sam Goss, inventor of a portion of the printing press later used by the *Chicago Tribune*. Parker Practice School is located in the background. (Photo courtesy of the Special Collections and Preservation Division, Chicago Public Library.)

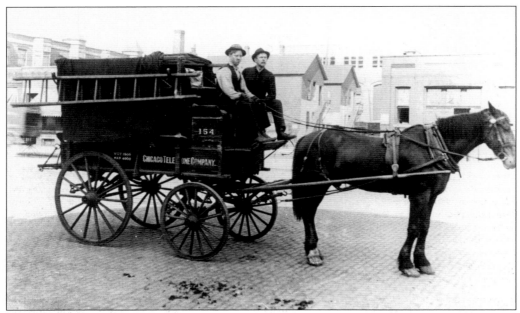

CHICAGO TELEPHONE COMPANY, C. 1880. With the formidable introduction of the telephone to society, cities worked fairly quickly to establish service. Early repair units, such as the 154, were sent out to fix services and other related problems. Horse-drawn carriages were common until the 1920s. (Photo courtesy of Mr. Gavin Weir Sr.)

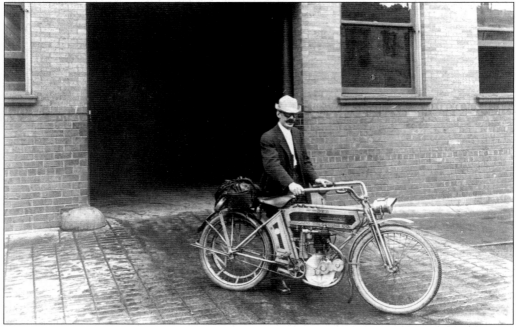

CHICAGO TELEPHONE COMPANY. Motorized vehicles replaced the earlier horse and buggy mode of transportation, providing quick service to customers. (Photo courtesy of Mr. Gavin Weir Sr.)

Two
CREATING COMMUNITY

Communities start taking shape as the inhabitants find ways of creating social structures. These structures consist of social groups, churches, schools, entertainment establishments, and institutions serving the needs of the locals. Although only a few of the churches are represented in this chapter, many types existed. Englewood was home to Catholic, Protestant, and Jewish houses of worship, and the range was incredible. One of the first important institutions established in Englewood was the Cook County Normal School. Completed in 1868, it was built on 10 acres of land donated by developer L.W. Beck. The building housed a training facility for future teachers and attracted a large professional and business class. Other early social organizations were business associations, sports clubs, and churches, all of which helped to constitute the social activities of the community. Parks also played a significant role in the leisure and sports-based activities for Englewood and they provided a respite from daily life.

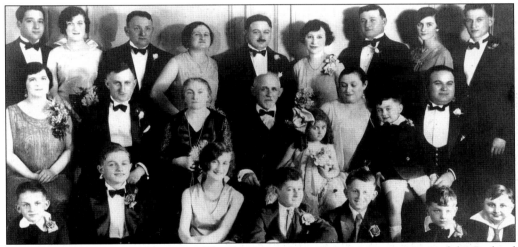

BASKIND FAMILY PORTRAIT, 1930. This family portrait spans three generations of the Baskind family and was taken at the 50th wedding anniversary of Moses and Frada Baskind. Moses Baskind owned a jewelry and repair shop in Englewood. Pictured, front row, from left to right, are: Leonard Kernis, Alvin Kernis, Jessie Baskind Bergman, Jerry Baskind, Irving A. Kernis, Jerome Holland, Myron Baskind; middle row, left to right: Helen Baskind, Albert Baskind, Frada Baskind, Moses Baskind, Thelma Jean Holland, Hannah Baskind Holland, Wesley Holland, M.Z. Holland; back row, left to right: Adrian Stern, Claranet Baskind Stern, Jacob Kernis, Ida Baskind Kernis, Nathaniel Baskind, Marion Baskind, David Baskind, Anna Mae Baskind Dubelle, Norman Kernis. The extended family primarily lived and worked in Englewood. Most went on to achieve success, a few highlighted individuals include: M.Z. Holland owned Holland's Jewelers; Norman Kernis opened Norman Jewelers in 1939, a mainstay in Englewood; Nathaniel Baskind became a doctor and studied skin cancer in Vienna in 1926. He established his medical practice in Englewood and remained in the community his entire career. His wife, Marion was active on the Woman's Board at the Englewood Hospital. Irving A. Kernis went on to become a Doctor of Optometry. (Photo courtesy of Dr. Irving A. Kernis.)

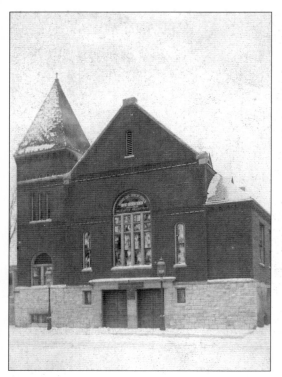

EARLY PHOTOGRAPH OF COVENANT BAPTIST CHURCH, COMPLETED IN 1888. Covenant Baptist Church was initiated with approximately 100 members formerly of the First Baptist Church of Englewood. The church grew in size, as did its commitment to the community. In 1938, it celebrated its 50-Year Anniversary with a series of events. President Franklin Delano Roosevelt sent a letter of congratulations, indicating the importance of spiritual guidance during the Depression and referencing the encroaching disorder in Europe. (Photo courtesy of the Special Collections and Preservation Division, Chicago Public Library.)

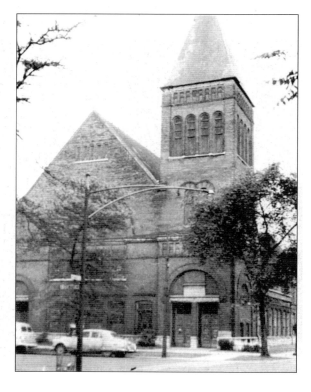

THE ENGLEWOOD METHODIST CHURCH, 1962. The church was founded in 1873. Its congregation was at its height in the mid-1930s, but as the population shifted to African American in the 1950s and 1960s, membership declined. As with many churches in the community, they regrouped and focused on the needs of the new congregation and poured their energies into improving the community through social activities. (Photo courtesy of Richard Stamz.)

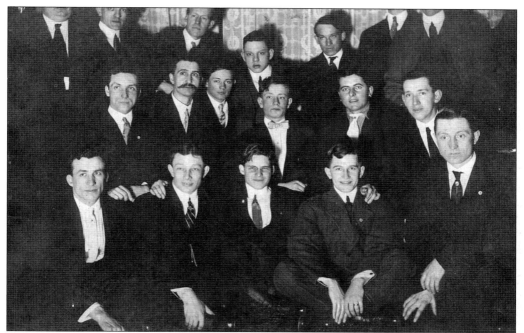

BACHELOR'S CLUB OF COVENANT BAPTIST CHURCH. Both of these photos indicate the rich history of the congregation and its social activities. Most churches in Englewood established social clubs and events for their constituencies. Many residents of the neighborhood met and married through these clubs, raised money for social causes, and sent their children to church-run schools. (Photo courtesy of the Special Collections and Preservation Division, Chicago Public Library.)

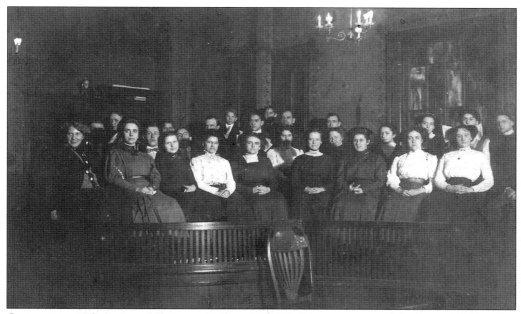

CHOIR OF THE COVENANT BAPTIST CHURCH, 1903. (Photo courtesy of the Special Collections and Preservation Division, Chicago Public Library.)

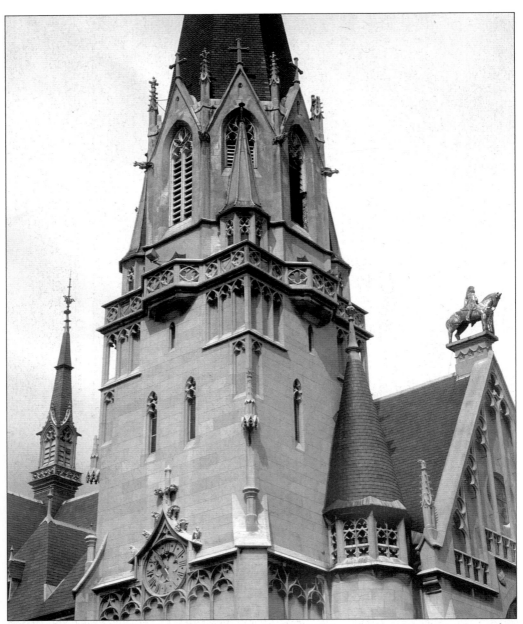

ST. MARTIN'S CATHOLIC CHURCH, 1991. St. Martin's, 59th and Princeton Avenue, was first organized in 1886 as a German congregation serving the Englewood area. Before long, the congregation grew and to better serve parishioners, the cornerstone for the present structure was laid in 1894. The church opened to the public in November of 1895 and was considered an excellent example of German gothic style, complete with stained-glass windows and an impressive interior. (Photo courtesy of Rolf Achilles.)

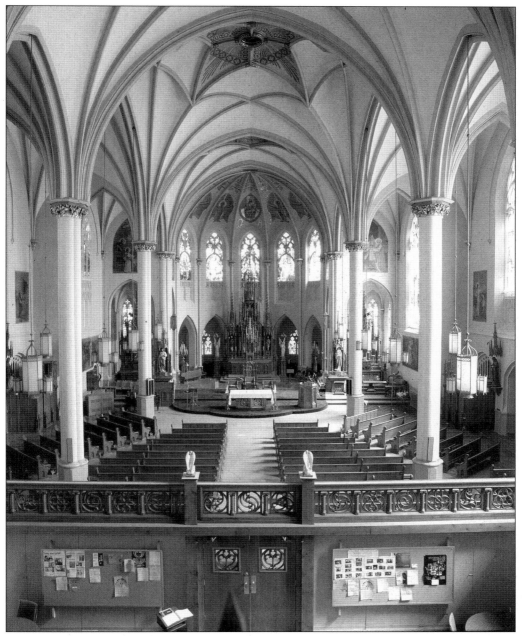

INTERIOR OF ST. MARTIN'S, 1991. Many of the statues, alters, and confessionals were carved from oak. German artisans created most of the original interior elements with materials brought in from Germany. (Photo courtesy of Rolf Achilles.)

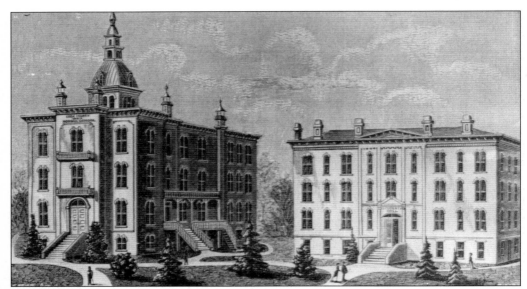

SKETCH OF THE COOK COUNTY NORMAL SCHOOL, 1880-1900. The school was a training center for teachers, allowing them to learn their trade in an academic setting. The philosophy of a normal school was twofold; it was to serve as a school where teachers would be supplied adequate information for the future needs of the population and provide a model school to give students a theoretical background as part of their practice. The original school opened in 1859, without a permanent home. At the insistence of the school commissioner, John F. Eberhart, the county Board of Supervisors secured funds to build and maintain a school. Competition from various regions was intense, and the school first opened in a temporary location in Blue Island. The Cook Country Normal School completed its permanent building in 1868 on 10 acres of land donated by real estate developer L.W. Beck. This school was one of the key anchors in the community, drawing in a professional and middle-class population. Indeed, because of its location, Englewood was seen as a model for progressive education. (Photo courtesy of the Special Collections and Preservation Division, Chicago Public Library.)

THE COOK COUNTY NORMAL SCHOOL'S BUILDING, 1903. Located at 6930 S. Stewart Avenue, the Cook County Normal School and the Parker Practice School became a campus. It included the Parker Practice High School and the Parker Junior High School, both of which adhered to the philosophy of the normal school practices. (Photo courtesy of the Special Collections and Preservation Division, Chicago Public Library.)

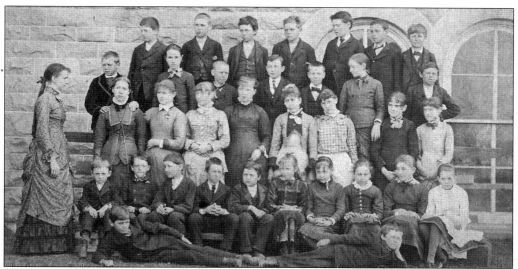

A COOK COUNTY NORMAL SCHOOL CLASS PHOTOGRAPH, 1881. (Photo courtesy of the Special Collections and Preservation Division, Chicago Public Library.)

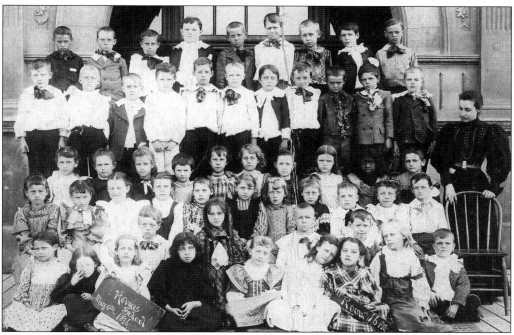

CLASS PHOTOGRAPH, HOLMES SCHOOL, 1896. In addition to Holmes, many other schools made their mark on the community, including Englewood High School. The first school in the neighborhood was erected in 1859, housing an elementary school, high school, the first normal school, and the first church services. As the student body grew, the schools shifted to accommodate the growing community needs. Englewood High School, like many schools in the area, moved location until it found a permanent home at 62nd and Stewart. Additions were built bit by bit over the years, making it a showcase institution. (Photo courtesy of the Special Collections and Preservation Division, Chicago Public Library.)

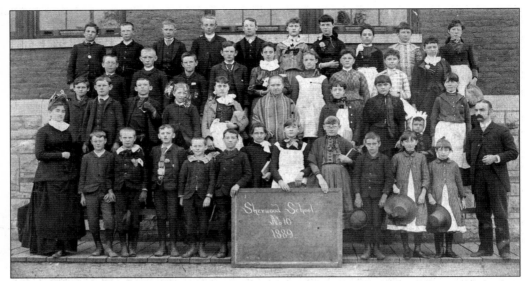

CLASS PHOTOGRAPH, SHERWOOD ELEMENTARY SCHOOL, 1889. Originally established in 1885, Sherwood had eight classrooms. A 12-room addition was added to the school in 1912. (H.J. Dewey, photographer, 516 Maple Street, Englewood. Photo courtesy of the Special Collections and Preservation Division, Chicago Public Library.)

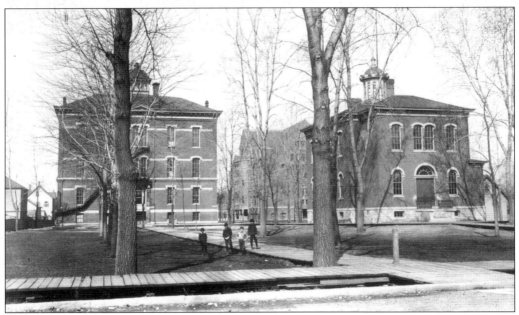

LEWIS CHAMPLIN GRAMMAR SCHOOL, ON ENGLEWOOD AVENUE, c. 1900. This school was named after Dr. A.H. Champlin, a member of the County Board of Education. The Cook County Normal School was located in this building until it was moved to its permanent home on Stewart Avenue. During the early years of Englewood, schools were housed in a common location, and then rebuilt according to population needs. The middle building at the rear is Englewood High School. (Photo courtesy of the Special Collections and Preservation Division, Chicago Public Library and Pullman Bank and Trust.)

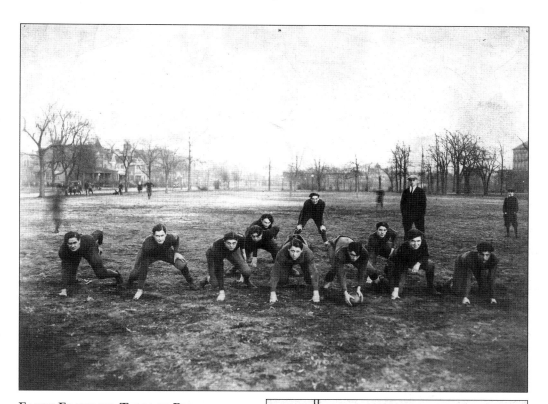

EARLY FOOTBALL TEAM OF PARKER HIGH SCHOOL, 1917. Parker High School was an exemplary model for education. During the early part of the 20th century, as the school served more students it offered a range of classes; from technical to academic. Additionally, it offered the opportunity to participate in sports and social clubs. For the time, it had a very high success rate, with about 20-25 percent of its students attending higher education. (Photo courtesy of the Special Collections and Preservation Division, Chicago Public Library.)

PARKER HIGH SCHOOL GRADUATION BOOKLET, 1952. This commencement booklet from the class of 1952 lists the program, graduates, and the Parker Loyalty song. (Photo courtesy of Dr. Irving A. Kernis.)

Parker High School

Commencement

Exercises

Wednesday, January 30, 1952

Eight p.m.

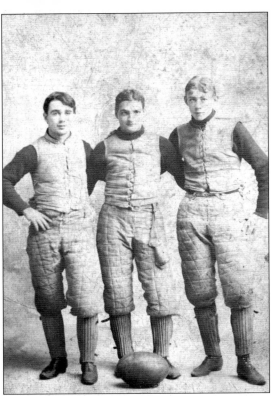

THE PRINCETON A.C. FOOTBALL TEAM, 1896. Pictured, from left to right, are: Billy Weatherson, Jimmie Guy, and Thomas Corr. Schools and churches formed a major crux of services to the community. (Photo courtesy of the Special Collections and Preservation Division, Chicago Public Library.)

RUGBY CLUB, 1880–1910. (Photo courtesy of the Special Collections and Preservation Division, Chicago Public Library.)

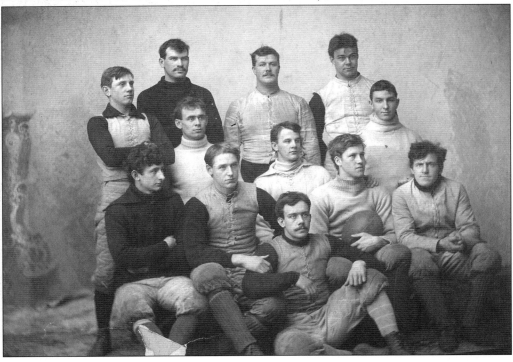

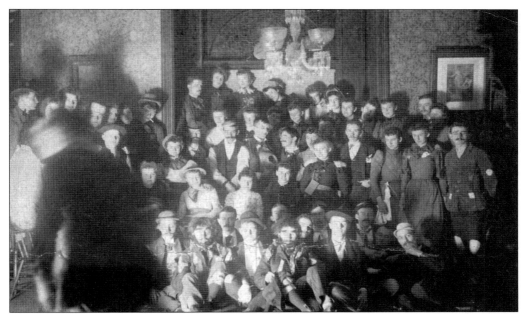

HARD TIMES PARTY, DECEMBER 29, 1891. The Englewood Cycling Club sponsored this annual event. Social clubs and events were diverse in Englewood. (May & Weed, photographers, Englewood, Ill. Photo courtesy of the Special Collections and Preservation Division, Chicago Public Library.)

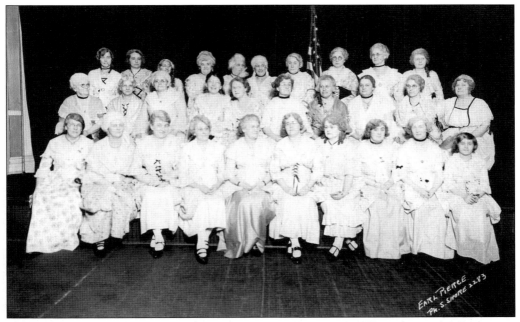

HOSTESSES OF THE 1ST METHODIST EPISCOPAL CHURCH, WASHINGTON'S BIRTHDAY DINNER, C. 1920S. Englewood residents were patriotic in their activities, always celebrating holidays with flair, like the 4th of July and Washington's Birthday. (Photo courtesy of the Special Collections and Preservation Division, Chicago Public Library.)

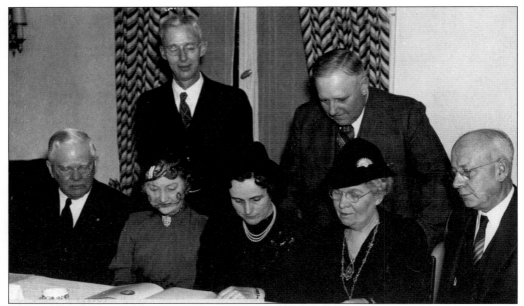

ENGLEWOOD HISTORICAL ASSOCIATION MEETING, NOVEMBER 1937. Englewood's Historical Association was located at the Hirim Kelly Library. Pictured, from left to right, are: Sen. Charles Deneen, Minnie S. Clark, Viola Neeson, Florence Deneen, Willis E. Tower, J. Penhallegon, and Kenneth Goodspeed. The local historical society was founded to record the community's history and performed an important service to the area. In the 1920s, the Chicago Public Library helped to establish local historical societies, including this one at Hirim Kelly Library. (Photo courtesy of the Special Collections and Preservation Division, Chicago Public Library.)

ENGLEWOOD'S HISTORICAL ASSOCIATION'S JUNIOR CLUB, 1941. Youth were encouraged to take part in the activities of the association. (Photo courtesy of the Special Collections and Preservation Division, Chicago Public Library.)

34

A Photo Exhibition Sponsored by the Englewood Historical Association, 1940. This documentation indicates what was important to the community of Englewood. The show included images of people, buildings, and schools. Many of the images used in this book can also be located in the Special Collections Division of the Chicago Public Library, Harold Washington Library. (Photo courtesy of the Special Collections and Preservation Division, Chicago Public Library.)

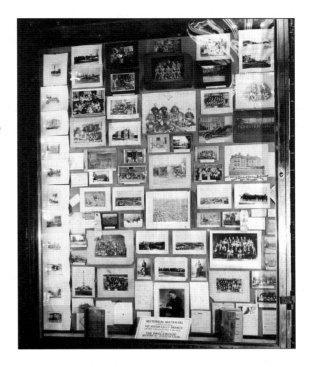

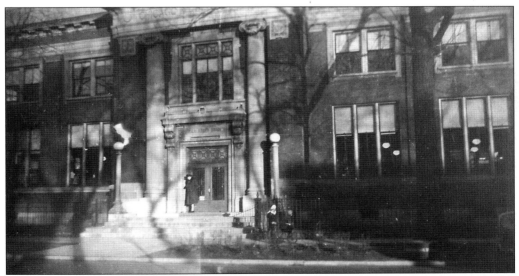

Hirim Kelly Library Building, c. 1930. Located at 62nd Street and Normal Avenue, the library opened to the public in June 1911. Hirim Kelly, a South Side merchant, donated a gift of $200,000 for the building. Prior to the library, Englewood utilized a library station, where residents could request books from the main library and wait until the books were sent. The Kelly Library Branch is still a wonderful resource to the community, organizing programs for children and families. (Photo courtesy of the Special Collections and Preservation Division, Chicago Public Library.)

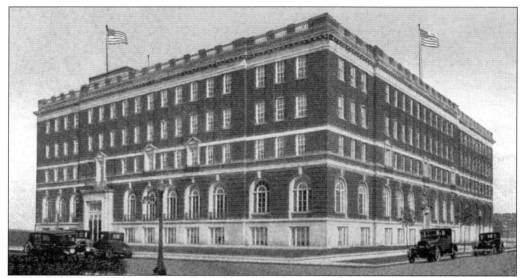

Postcard of the Englewood Department Y.M.C.A. of Chicago, c. 1925. The Englewood Y.M.C.A. was first organized in 1886 and occupied three rooms in the F.G. Thearle Jewelry Store building at the corner of 63rd Street and Wentworth. In 1888, a new building was constructed on a small 60-by-125-foot lot. After 1923, a new building, presumably the one shown in this image, was built to serve the community. (Photo courtesy of the Special Collections and Preservation Division, Chicago Public Library.)

St. Bernards Hospital, 1910–1920, Located Between 63rd and 64th Streets and Harvard. Norman Kernis, owner of Norman Jewelers and highlighted in chapter three, was finance chairman of St. Bernards Board of Directors for 13 years starting in 1983. Today the hospital is run by Sr. Elizabeth Van Straten, RHSJ, CEO since 1992. She has worked to greatly improve the facility and has contributed to the Englewood community. Under her leadership, the Professional Pavilion was completed and she worked with the city to develop a residential housing area called Bernard Place. (Photo courtesy of the Special Collections and Preservation Division, Chicago Public Library.)

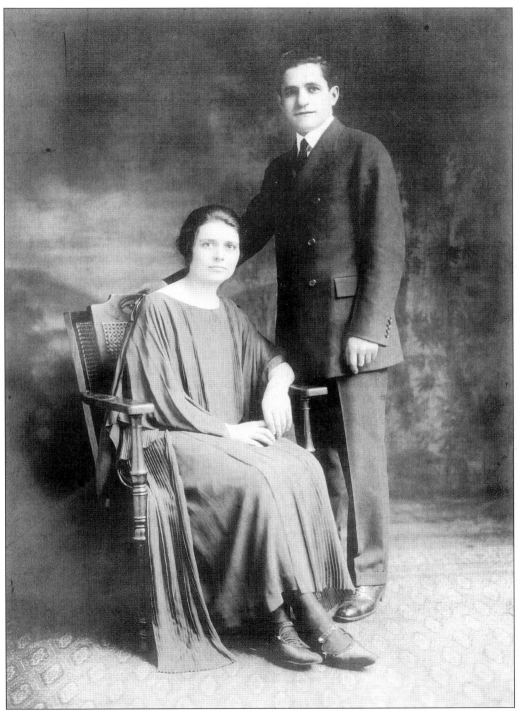

PORTRAIT OF FANNIE KAPLAN BORTZ AND EDWARD BORTZ, C. 1920. Bortz owned the men's clothing store at 6155 S. Halsted Street from 1920 to 1940. Business owners often lived in the community. (Photo courtesy of Mrs. Frances Kernis and son, Mr. Jeffery Kernis.)

JEWEL BOYD CLARKE KERNIS, 1949.
Irving Kernis married Jewel on February
28, 1948. She is pictured at a small park
next to the train embankment on 67th
Place. The Kernis's lived at 6718 S.
Halsted. (Photo courtesy of Dr. Irving
A. Kernis.)

DANIEL CLARKE, 1952. Daniel, son of
Irving and Jewel, graduated from
Wentworth Elementary School and
finished high school at Parker. After
graduation he enlisted in the U.S. Army
and served in Korea. He is pictured here
at Ft. Sheridan. (Photo courtesy of Dr.
Irving A. Kernis.)

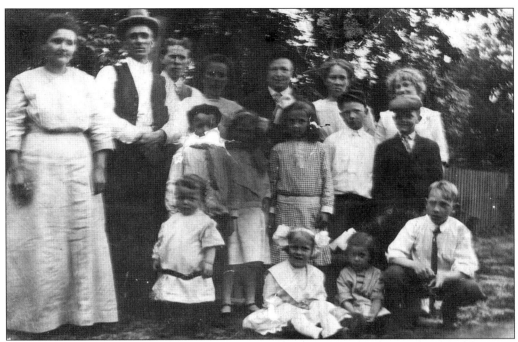

PETERSON FAMILY, C. 1900. As was typical for many, extended families lived in the same communities, helping to build businesses and forming the social bonds that kept neighborhoods thriving. Caroline Kuhl, pictured far left, married Alfred Peterson, directly to the right. Caroline's parents, John and Margaret Kuhl, were some of the earliest settlers in Englewood. John Kuhl had an industrial-scale repair business. The Kuhl's had 13 children and raised them on a farm at 6129 S. Throop. Pictured in the first row, second from the right, is Margaret Kuhl Peterson, daughter of Caroline. Margaret married James Doyle. His father, Michael Doyle, who started a printing press in West Englewood, was one of the seven original families to settle in that area. He became a prominent member of the business community and the neighborhood. Margaret and James had seven children, one of whom is Carol Doyle Schuberth. Generations of the Kuhl-Peterson-Doyle family lived in the Englewood area from the 1860s to the 1960s, 100 years of community involvement. (Photo courtesy of Carol A. Schuberth.)

CAROL ANNE DOYLE SCHUBERTH, 1940. Carol Schuberth was five years old in this photograph. As a teenager she worked at Woolworth's Department Store in Englewood. After she married, she and her husband, Henry (Hank) Schuberth lived in Englewood until 1957. After six years in other Chicago neighborhoods, they moved back and remained for a few more years. They finally moved to the Ashburn neighborhood on the Southwest Side of Chicago and remain there today. Hank and Carol Schuberth met, married, and lived in Englewood. After raising eight children in Englewood and Ashburn, Carol pursued a degree in fine arts from Daley College and St. Xavier and received scholarships from the School of the Art Institute. (Photo courtesy of Carol A. Schuberth.)

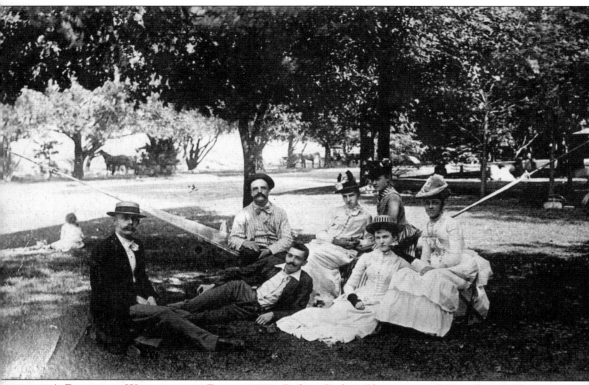

A PICNIC IN WASHINGTON PARK, 1889. Before Ogden, Sherman, and Hamilton Parks were built, many residents spent their time in Washington Park, located today at 5531 S. Martin Luther King Drive. Washington Park was one of the largest public spaces on the South Side. In 1869, the Illinois State Legislature established the South Park Commission and started park development plans on over 1,000 acres of land. Originally a section of South Park, the name was later changed to honor the first president George Washington. (Photo courtesy of Pullman Bank and Trust.)

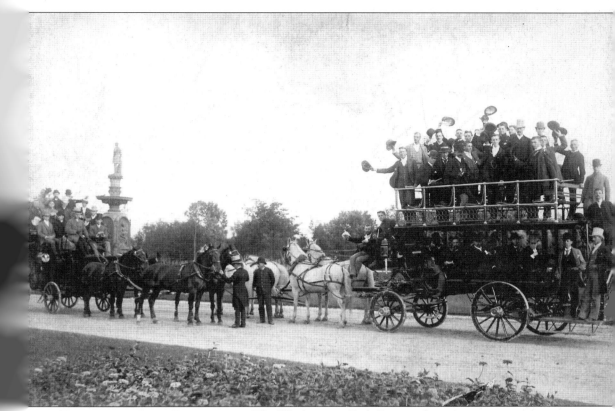

WASHINGTON PARK RACES, 1889. The Washington Park Racetrack was a prestigious private club located near Washington Park. (Photo courtesy of the Special Collections and Preservation Division, Chicago Public Library.)

OGDEN PARK, C. 1925. Parks servicing Englewood include Ogden, Hamilton, and Sherman Parks, which were 3 of 10 parks that were part of a revolutionary movement in the city to provide respite from the overcrowded neighborhoods and from less amenable parks that already existed in the inner-city. These three parks were designed by famous landscape architects the Olmsted Brothers and the renowned architects of D. H. Burnham and Company. Each park was designed as an individual entity. President Theodore Roosevelt commended Chicago on its new park system and its variety of recreational, educational, and social services, which proved to be a model for parks in other national cities. (Photo courtesy of the Chicago Park District's Special Collections.)

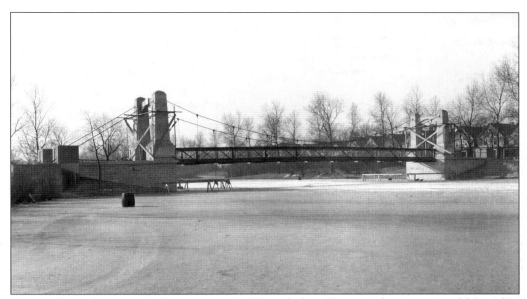

OGDEN PARK SUSPENSION BRIDGE, 1928. Named after Chicago's first mayor and located at 6500 S. Racine on 60 acres of land, Ogden Park contained a meandering waterway, ball-field, and meadow. The waterway was filled in 1940 to enlarge the ball-fields. Ogden remains one of the most favored spots in the community for everyone from seniors to youth. The following images give a sense of the parks' early years, from the construction to landscape maturity. (Photo courtesy of the Chicago Park District's Special Collections.)

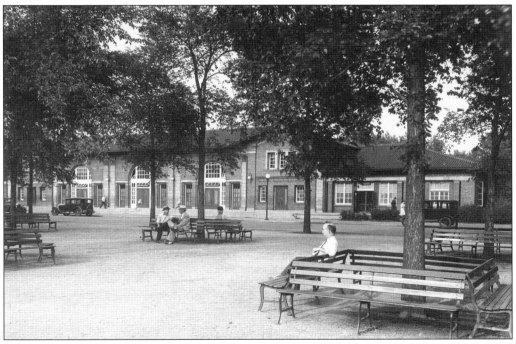

OGDEN PARK FIELD HOUSE, C. 1920s. (Photo courtesy of the Chicago Park District's Special Collections.)

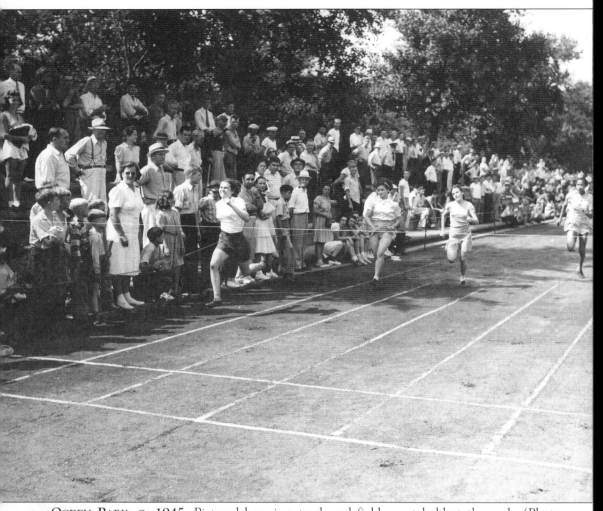

OGDEN PARK, C. 1945. Pictured here is a track and field event held at the park. (Photo courtesy of the Chicago Park District's Special Collections.)

OGDEN PARK, MAYOR RICHARD J. DALEY ATTENDING A CEREMONY, C. 1960. Mayor Daley often frequented events in Chicago parks, affording him an opportunity to meet with residents and campaign. Other individuals pictured are unknown. (Photo courtesy of the Chicago Park District's Special Collections.)

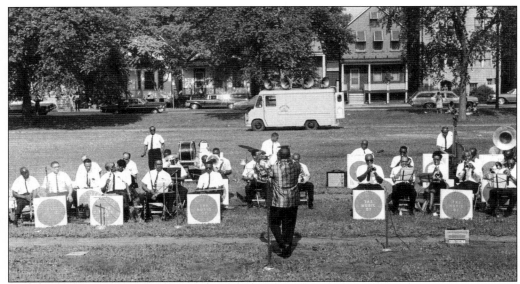

OGDEN PARK, C. 1965. A band plays for a community-based event in this mid-1960s photo. During the 1950s and 1960s, the neighborhood ethnicity and racial make-up started to change. African Americans found Englewood a desirable residential location, while ethnic whites moved further south, west, or to the suburbs. (Photo courtesy of the Chicago Park District's Special Collections.)

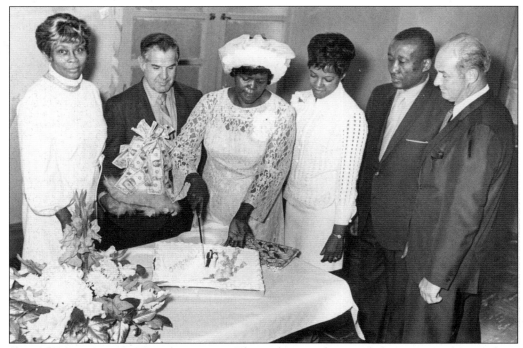

OGDEN PARK, SENIOR WEDDING, 1979. The park not only provided many ways for people to interact, but also offered services that went beyond general recreational activities, including weddings. (Photo courtesy of the Chicago Park District's Special Collections.)

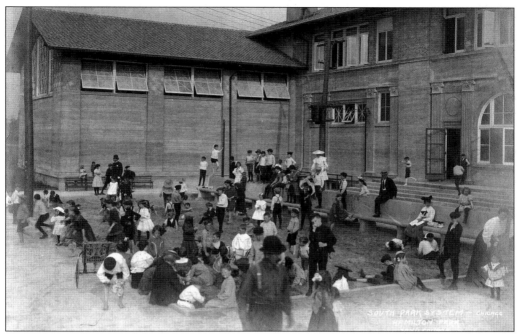

HAMILTON PARK, SAND COURTS, C. 1910. Hamilton Park is named after Alexander Hamilton, first Secretary of the Treasury and advisor to the first president, George Washington. He was killed in a duel with Aaron Burr. The murals located in the fieldhouse represent the political and historical themes of the United States and were created by artist John Warner Norton. (Photo courtesy of the Chicago Park District's Special Collections.)

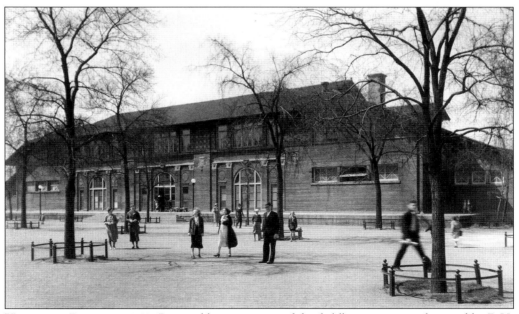

HAMILTON PARK, C. 1940. Pictured here is a view of the fieldhouse exterior designed by D.H. Burnham and Company. (Photo courtesy of the Chicago Park District's Special Collections.)

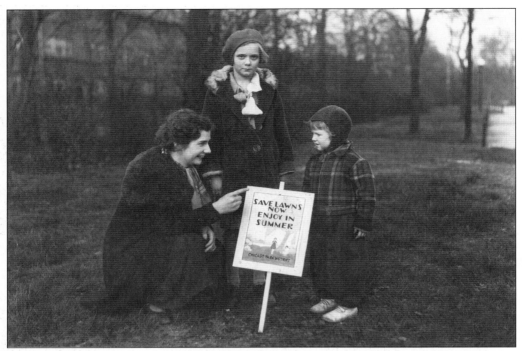

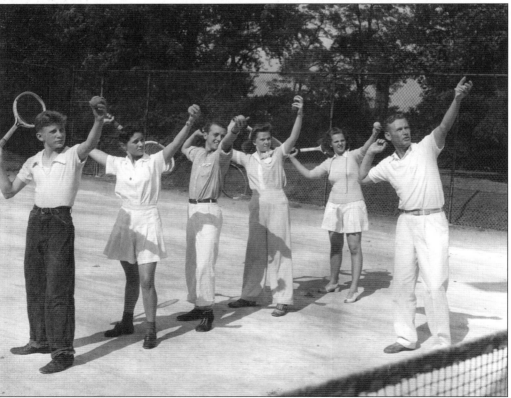

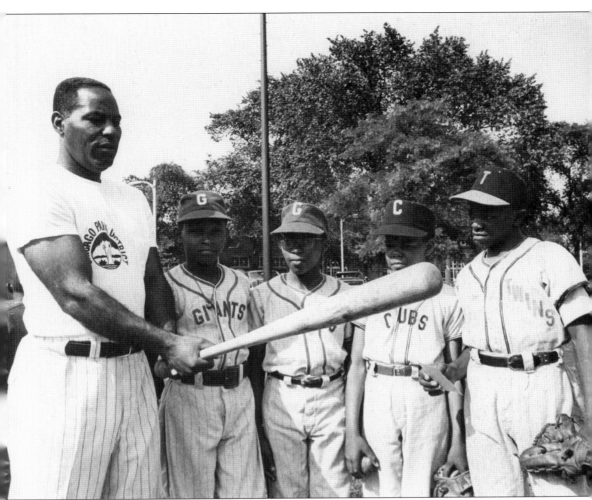

HAMILTON PARK, C. 1970. A major league player conducts baseball camp for young boys. (Photo courtesy of the Chicago Park District's Special Collections.)

Opposite, Top: **HAMILTON PARK, C. 1930S.** This image depicts the conservation methods the Chicago Park District sometimes employed. By alerting patrons of the need to keep the lawn in good shape, they encouraged participation through awareness. (Photo courtesy of the Chicago Park District's Special Collections.)

Opposite, Bottom: **HAMILTON PARK, FREE TENNIS SCHOOL, JUNE 23, 1944.** The parks emphasized active recreation through sports clinics. (Photo courtesy of the Chicago Park District's Special Collections.)

SHERMAN PARK, 1307 W. 52ND STREET. Sherman Park is named after John Sherman, the founder of the Chicago Union Stockyards and father-in-law of the park's architect, Daniel H. Burnham. Sherman's 60 acres of land incorporates a meandering waterway surrounding an island of ball-fields. The buildings, which include a fieldhouse, gym, and locker facility, sit at the north end of the park. The park itself is located outside the official boundaries of Englewood, however, it still served the community along with the northern section whose residents often worked in the Chicago Union Stockyards and packinghouses. (Photo courtesy of the Chicago Park District's Special Collections.)

SHERMAN PARK, LIBRARY, C. 1930. Built in 1905, the Sherman Park Library was a branch of the Chicago Public Library system. When the library outgrew its room in the fieldhouse, a new structure was built on the southeast side of the park. This beautifully designed library provided services to people in addition to the Hirim Kelly Library. (Photo courtesy of the Chicago Park District's Special Collections.)

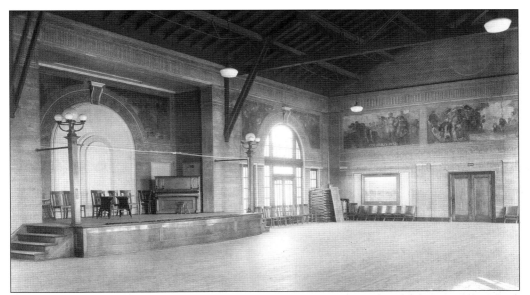

SHERMAN PARK, AUDITORIUM WITH MURALS, C. 1930. The murals depict scenes from American history in the Midwest painted by students from the School of the Art Institute. (Photo courtesy of the Chicago Park District's Special Collections.)

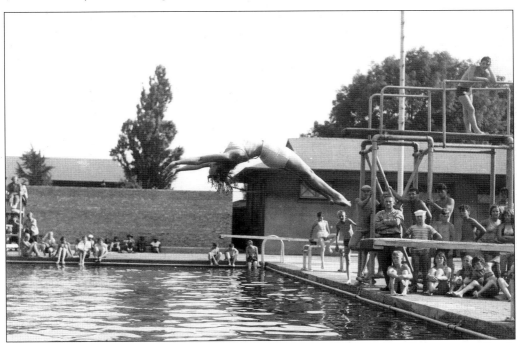

SHERMAN PARK, 1950. This diver took first place in diving in the area II swim meet, South Side Parks, sponsored by the Chicago Park District. Many Chicago parks have swimming pools for their patrons and the South Park Commission built these amenities because of the importance placed on the health and well-being of the city's residents. (Photo courtesy of the Chicago Park District's Special Collections.)

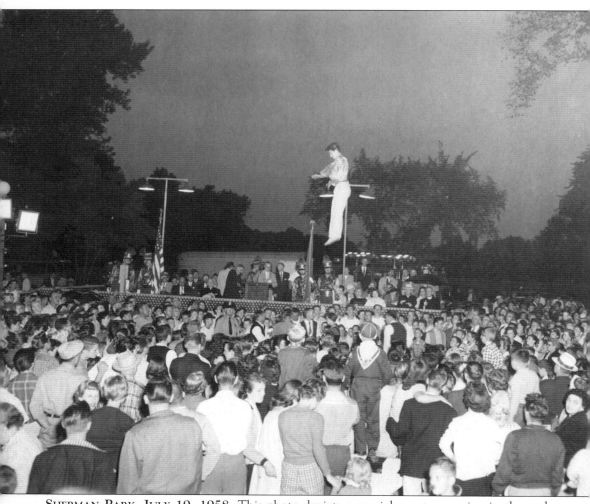

SHERMAN PARK, JULY 19, 1958. This photo depicts a special event occurring in the park. (Photo courtesy of the Chicago Park District's Special Collections.)

SHERMAN PARK, JULY 10, 1985. From the time of the park's introduction to the present day, some structures have been torn down, restored, or replaced. Yet the mission of creating a positive recreational space still applies, as the Chicago Park District employs numerous staff to create and implement wide-ranging cultural programs and recreational events. (Photo courtesy of the Chicago Park District's Special Collections.)

HOLMES MURDER CASTLE. This photo of the former home of Henry Holmes does not quite fit into any category in this book, yet it is important to focus on the image and history briefly. Dr. Henry Holmes—aka Herman W. Mudgett—was a serial killer who murdered individuals in his home. Before he settled in Chicago in 1886, he led a life of crime. He received a job in an Englewood drugstore by lying about his background, saying that he received a degree from the university in Ann Arbor, Michigan. He planned and built a two-to-three story home at 701–703 W. 63rd Street. Because of the anonymity of the city, he was able to lure individual Chicagoans, and those coming for the World's Columbian Exposition, to his home where they were tortured and then murdered. His home hid a maze of passages, chambers, and instruments to help him with the murders, and he discarded the bodies by donating them to medical practice. His trail of murder around the country led police to him and in 1896, he confessed to his crimes. (Photo courtesy of the Chicago Historical Society.)

Three
THE BUSINESS DISTRICT

One of the key elements that brought the many visitors and consumers to the community was Englewood's shopping district. In the early part of the 20th century, this economic stronghold was Chicago's second largest commercial enterprise outside of the downtown Loop area. Public transportation, along with the opening of Sears Roebuck & Company and Weiboldt's which served as anchor department stores, helped to shape the community's financial solvency. Some of the most prestigious stores were located on Halsted between 63rd and 65th Streets.

In 1918, merchants formed what was to become a long-standing organization, the Englewood Business Men's Association (EBMA). This group included members from small and large businesses and the Chicago City Bank. The main goals of the association were to encourage beneficial business practices, to promote legislation, to participate in the community, to promote cooperation with neighborhood residents, and to promote all the businesses as a collective. In the past, it had formidable leaders and today it is run by Audrey Drew who has been at the helm since 1978.

The history of the commercial district will be highlighted through Norman Jewelers, founded in 1939, the Chicago City Bank, currently Pullman Bank and Trust, and the Englewood Business Men's Association. These long-standing entities are the only remaining businesses from the earlier years of the 20th century. These leaders have documented the history of the community through images, and have kept a high profile and strong connection to the neighborhood. Many of the other businesses that were part of the district are also shown through the photos in this section.

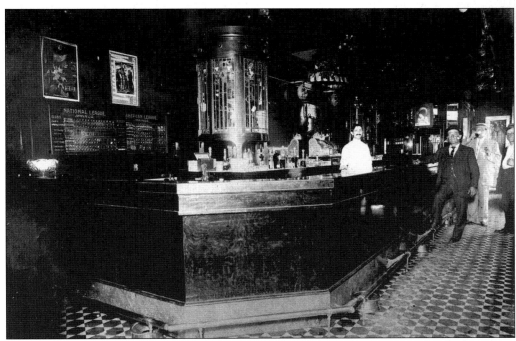

CLIFFORD BROS. SALOON, INTERIOR VIEW, 1915. Located at 6225 S. Halsted, the saloon moved their business into the original Chicago City Bank location. (Photo courtesy of Pullman Bank and Trust.)

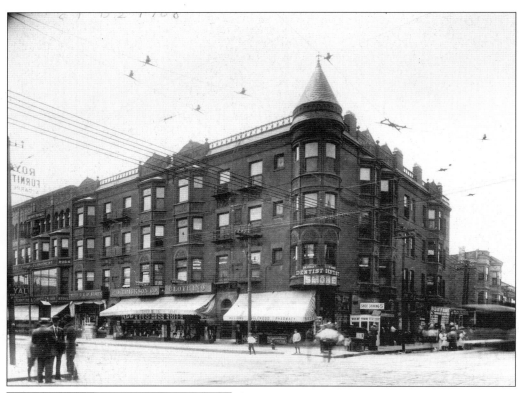

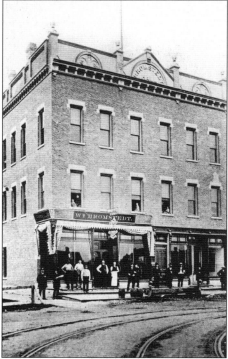

SOUTHWEST CORNER OF 63RD AND HALSTED STREETS, C. 1900. This particular corner served as a major thoroughfare for shoppers. Businesses built out from this central commercial spot. Kresge's chain store moved into this area. (Photo courtesy of Pullman Bank and Trust.)

NORTHWEST CORNER OF 63RD AND HALSTED STREETS, 1889. Bromstedt's was the street level store, however, this type of building shows the common practice of developing building and leasing space for a variety of retail and professional businesses at the same location. For example, in the 1920s, the New China Restaurant was located on the second floor. The corner of 63rd and Halsted Streets proved to be one of the most profitable corners in the city, becoming the epicenter of retail in the neighborhood. The Chicago City Bank (now Pullman Bank and Trust) built its final building on 63rd Street, southwest of this corner. An elevated public transit station was located close by, affording people the opportunity to travel to the shopping district. Walgreen's Drugstore stands on the site currently. (Photo courtesy of Pullman Bank and Trust.)

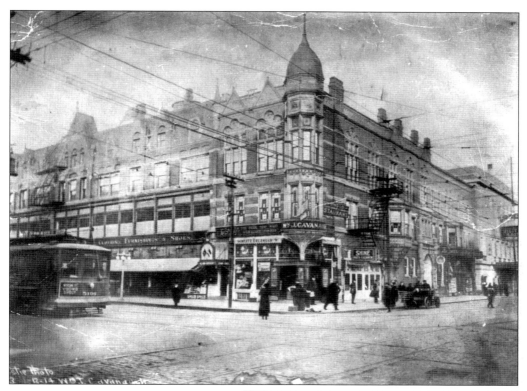

NORTHEAST CORNER OF 63RD AND HALSTED, 1914. Schlitz Brewing Company erected this three-story building before 1900. It was purchased later by Becker-Ryan for department store operations. (Photo courtesy of Pullman Bank and Trust.)

MR. FRANK KOHN, MANAGER OF BECKER-RYAN BUILDING, LOCATED AT THE NORTHEAST CORNER OF 63RD AND HALSTED. Before it was demolished and replaced with a Sears Roebuck and Company Store, the Becker-Ryan Department Store was one of the largest multi-unit commercial buildings in Englewood. The owners of the building expanded the department store by purchasing surrounding properties. Frank Kohn was also the first manager of the Englewood Sears Roebuck and Company Store. (Photo courtesy of Mrs. Frances Kernis and son, Mr. Jeffery Kernis.)

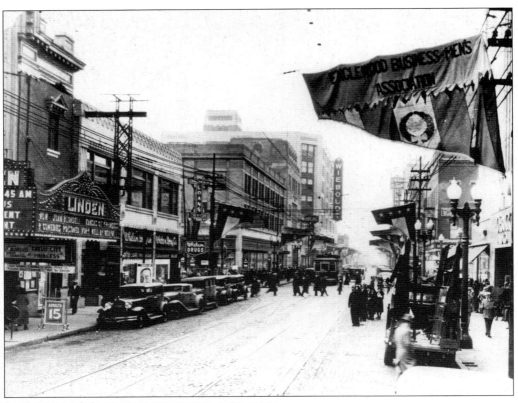

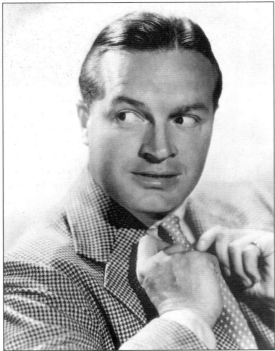

LOOKING WEST ON 63RD STREET, C. 1930s. In the forefront is the Linden Theatre, with the Chicago City Bank & Trust located just east of Weiboldt's department store. The Englewood Business Men's Association lined the street with banners, showing their presence and support of the commercial district. (Photo courtesy of Pullman Bank and Trust.)

BOB HOPE, 1946. Chicago was a major stop for any vaudeville act and Englewood was home to some of the more prominent theaters for these types of performances. Bob Hope once played at the Stratford Theatre. The Three Stooges, long known for slapstick on stage, and later their own television show, could also be seen at the Stratford. Benny Goodman was known to do shows early on in his career in Englewood, entertaining the crowds. (Photo courtesy of the Chicago Historical Society.)

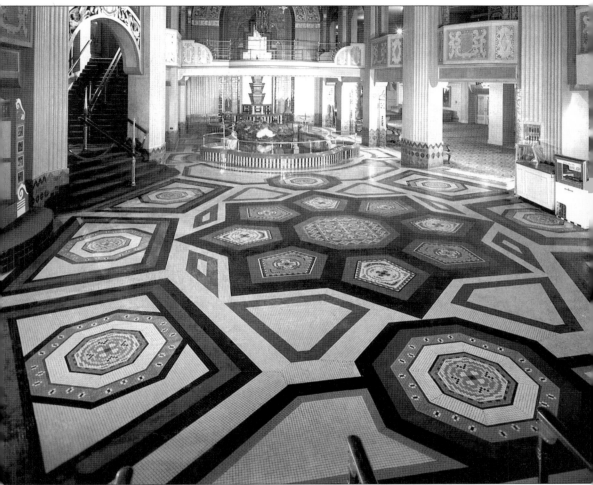

LOBBY OF THE SOUTHTOWN THEATRE, 1949; PHOTOGRAPH BY HEDRICH-BLESSING. A major entertainment venue on the South Side, the Southtown Theatre was a showcase movie theatre. The theatre was built by Balaban and Katz, prominent business partners specializing in theatre houses in Chicago. Built in 1931, it was one of the last of its kind. Its design was highly ornamental. Catering to the predominantly middle-class wealth of the area, the owners of the Southtown required the architects of their movie palaces to foster a sense of grandness. This particular theatre incorporated live swans and a large parking facility to attract people. The theatre closed in 1958. (Photo courtesy of the Chicago Historical Society.)

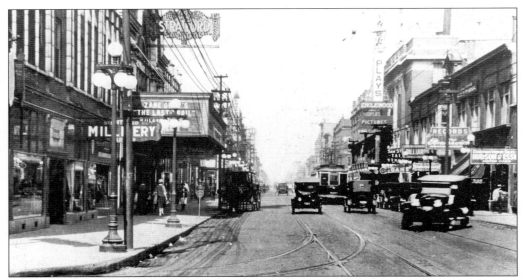

STREET SCENE AROUND 63RD AND HALSTED. The Stratford Theatre was located at 701 W. 63rd Street. Built in 1919, the theatre seated approximately 2,500 people. The Stratford was only one prominent theatre in the community that booked stage acts and movie screenings. Note the horse-drawn carriage near the theatre. Although auto transportation quickly changed the American lifestyle, carriages were still used by businesses and individuals up until the 1920s. (Photo courtesy of Pullman Bank and Trust.)

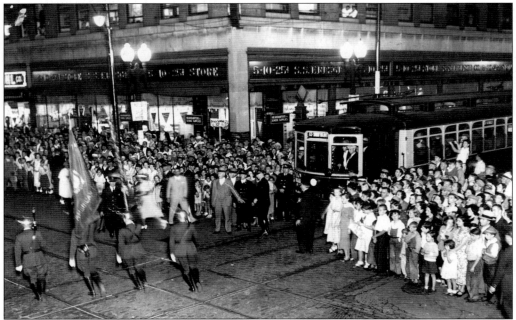

ENGLEWOOD DAY, SEPTEMBER 12, 1934. During the height of the Depression, Englewood residents still participated in neighborhood events. Parades and similar events would become standard for the community. Promotion of these events usually came from the Englewood Business Men's Association. (Photo courtesy of Pullman Bank and Trust.)

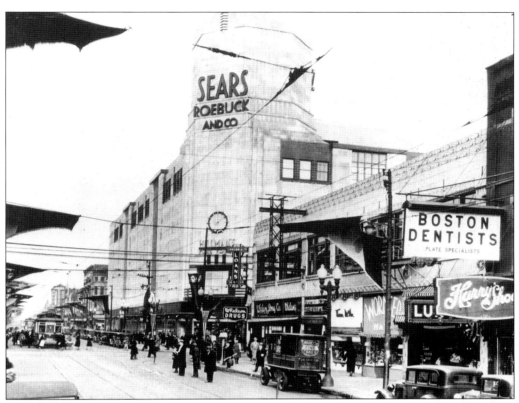

SEARS ROEBUCK AND CO., 63RD STREET AND HALSTED, C. 1935. Sears bought land for this outlet retail store in 1934 by purchasing the Becker-Ryan Building land. Although it opened during the Great Depression, the block-long store was a commercial success. It was also the first air-conditioned department store in the area, as the general lack of windows indicates. Its doors closed in 1976. (Photo courtesy of Pullman Bank and Trust.)

HALSTED STREET, BETWEEN 62ND AND 63RD STREETS, C. 1935. Pictured here is another view of the Sears building. The Empress Burlesque Theatre was located on the west side of the street. The location of the Empress was somewhat of a novelty for such a prestigious shopping center. Some people recall the shows, but others remember the high wooden fence built around the back of the building. Because the building had no air conditioning, the show women would cool off outside after the shows. The owner decided to shield the women from the probing eyes of neighbors. (Photo courtesy of Pullman Bank and Trust.)

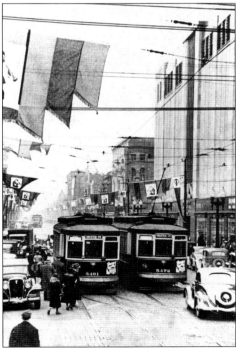

PORTRAIT OF HARRY KAPLAN, 1926. Kaplan, owner of H. Kaplan Construction Co., played a crucial role in the development of the business district. His company constructed many buildings and remodeled numerous others in Englewood from the 1920s to the 1940s. During this time, he developed 23 stores for the area, helping to shape the commercial landscape. Known as a generous man, he also helped others to foster their own businesses in the community, providing support and advice. Also inclined towards the new, Kaplan often purchased modern inventions and products that kept him on the forefront of technology and business. Kaplan's daughter, Frances Kaplan met her future husband, Norman Kernis, through a work relationship he had with her father, indicating the strong connection between business and community in Englewood. (Photo courtesy of Mrs. Frances Kernis and son, Mr. Jeffery Kernis.)

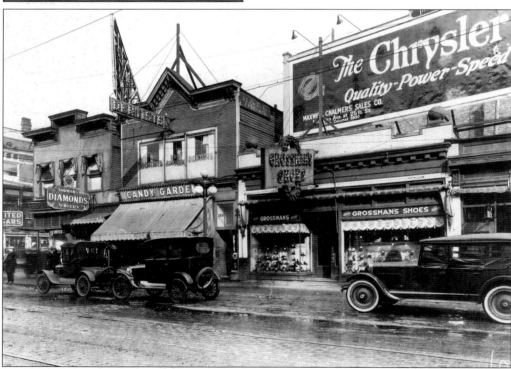

6307 S. HALSTED STREET, C. 1925. One of the many appealing aspects of Englewood's shopping district was its retail variety. This photograph highlights shoes, jewelry, and sundry stores. (Photo courtesy of the Pullman Bank and Trust.)

KRESGE'S DEPARTMENT STORE, 63RD AND HALSTED, 1948. Kresge's offered a variety of items that appealed to shoppers. It focused on range by providing high- and low-end items. (Photo courtesy of the Chicago Historical Society.)

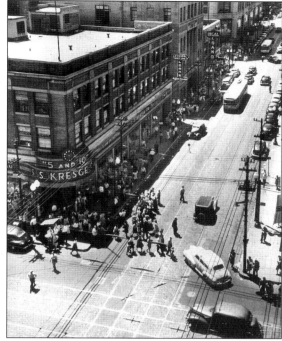

MIRACLE ON 63RD STREET, C. 1945. Shoppers flocked to the Englewood area during the holiday season to enjoy the festivities. Children surround Santa as he talks to the crowd. (Photo courtesy of Mrs. Frances Kernis and son, Mr. Jeffery Kernis.)

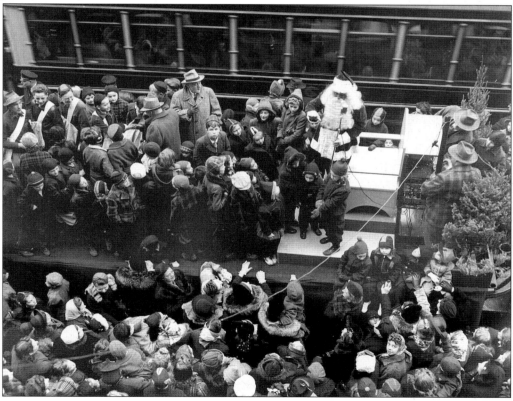

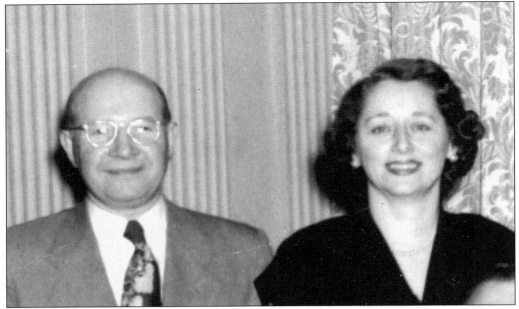

SAMUEL AND ETHEL SCHECHTER, 1950. Mr. Schechter was co-owner of the Honey Lou Bridal and Virginia Bridal Shops from 1949 to 1967. After WWII, the shops did incredible business as men, returning victorious from the war, were married. Carol Abrams, niece of Schechter, remembers the large ethnic weddings where brides of different nationalities sought specific types of gowns that reflected their heritage. (Photo courtesy of Marcia Schnider.)

HENRY KOBACK, C. 1950S. Henry Koback, brother-in-law of Sam Schechter, was the other owner of Honey Lou Bridal and Virginia Bridal Shops. He died in 1960 and Sam bought out Henry's share. (Photo courtesy of Carol Abrams.)

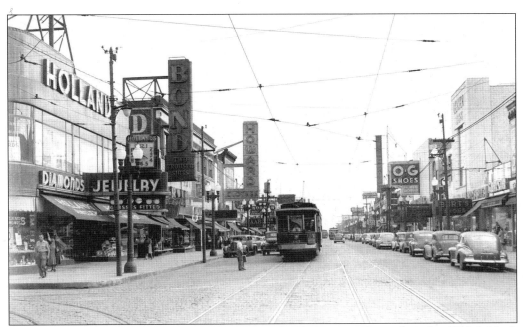

HOLLAND JEWELERS, C. 1945. Owned by M.Z. Holland, this store, located on the 6300 S. block of Halsted, was another icon of the business district. Holland was uncle to Norman and Irving Kernis. Holland's had competition from other jewelry stores including Norman Jewelers, keeping the rivalry friendly among family members. Additionally, this street scene shows the variety of stores in the district, including Lerner's clothing store, located at 6340 S. Halsted. There were several jewelry stores located in the main artery of the shopping district. Each store used several promotional methods to draw in customers. Irving Kernis remembers one promotional event that Holland Jewelers incorporated into its store. It cleared out its main front windows, placed a quartet in the space, and piped the music outside the store. Bing Crosby performed solo and was the lead singer for the group. (Photo courtesy of Mrs. Frances Kernis and son, Mr. Jeffery Kernis.)

PORTRAIT OF M.Z. HOLLAND, C. 1944. Holland first established his jewelry business in 1910. Holland sold radios and phonographs, in addition to operating his jewelry and repair enterprises. In nearly 30 years, he expanded his business to four stores, all located in Englewood. In 1937, he closed all but one on the 6300 block of Halsted and maintained it until the 1980s. The store was sold to Roger's Jewelry Store, becoming Roger's and Holland's. (Photo courtesy of Mrs. Frances Kernis and son, Mr. Jeffery Kernis.)

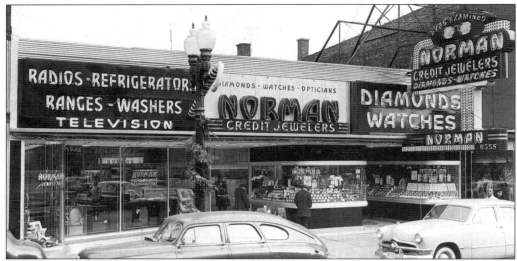

NORMAN JEWELERS, C. 1945. LOCATED AT 6355 S. HALSTED. Norman Jewelers was opened in 1939 by Norman Kernis. Kernis left his job as manager of Holland Jewelers to open his own store. He was active in the Englewood Business Men's Association, along with other community endeavors. Kernis expanded his business by opening a home appliance store in the 1940s, which also proved successful. Norman Jewelers is one of two remaining commercial enterprises in the district today, the other being Pullman Bank and Trust, formerly the Chicago City Bank. Eddie Perkins, pictured to the right behind the car, worked at Norman Jewelers in the 1940s and 1950s. (Photo courtesy of Mrs. Frances Kernis and son, Mr. Jeffery Kernis.)

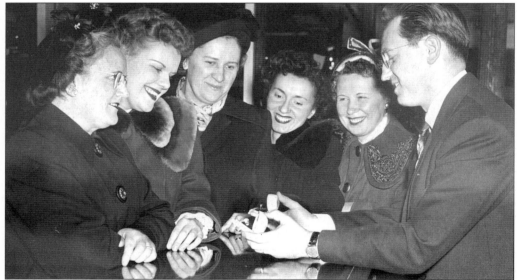

LADIES VIEWING RINGS AT NORMAN JEWELERS, C. 1945. Kernis's brother, Irving A. Kernis, worked in the store in the earlier days. Irving A. Kernis is now a retired Doctor of Optometry and the oldest police officer to graduate the Chicago Police Academy at the age of 71. As a young boy, Kernis worked for his uncle, M.Z. Holland of Holland Jewelers, learning the ins and outs of the business. Kernis' grandfather owned a jewelry and repair shop in the 6800 S. block of Halsted as well. (Photo courtesy of Mrs. Frances Kernis and son, Mr. Jeffery Kernis.)

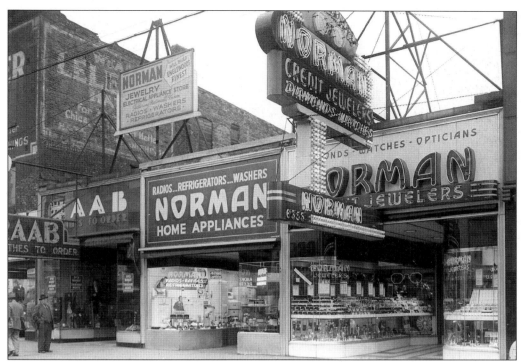

Norman Home Appliance Storefront, May 1949. (Photo courtesy of Mrs. Frances Kernis and son, Mr. Jeffery Kernis.)

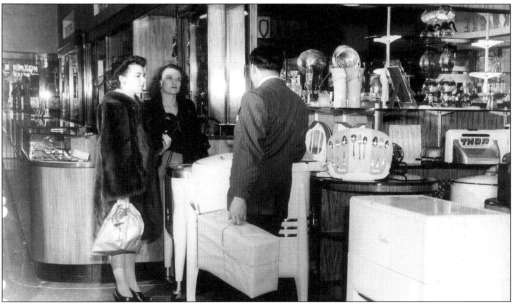

Women Shopping for Home Appliances, Norman Home Appliance Store, February 1946. After World War II, America saw a period of strong economic growth and a shifting pattern in the purchase of household goods. Appliances were now considered necessary conveniences. (Photo courtesy of Mrs. Frances Kernis and son, Mr. Jeffery Kernis.)

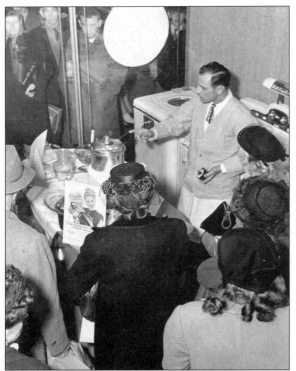

PROMOTIONAL EVENT DISPLAYING THE APPLIANCES AND WARES OF THE STORE, 1949. People from outside look on, as people watch the demonstration. (Photo courtesy of Mrs. Frances Kernis and son, Mr. Jeffery Kernis.)

PROMOTIONAL EVENT FOR NORMAN HOME APPLIANCES, C. 1946. Owners Norman and Frances Kernis's daughters take part in the festivities during the busy Christmas season. From left to right, Marilee, Barbara, and Pamela. The Kernis's took a number of photos over the years to highlight wares, and in the process, kept a record of the store's history. These images are representative of the businesses and commercial success of the area. As an independent retailer in a swarm of chain stores, theatres, and other types of ventures, Norman Kernis was able to capture the spirit of the shopping district. (Photo courtesy of Mrs. Frances Kernis and son, Mr. Jeffery Kernis.)

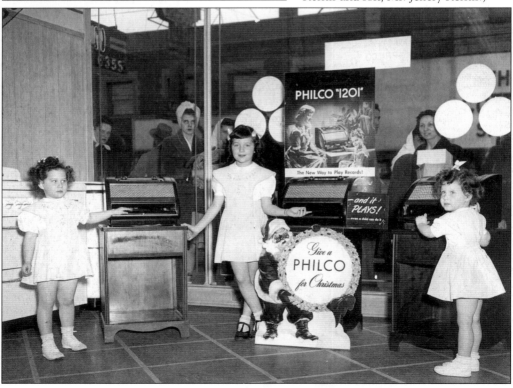

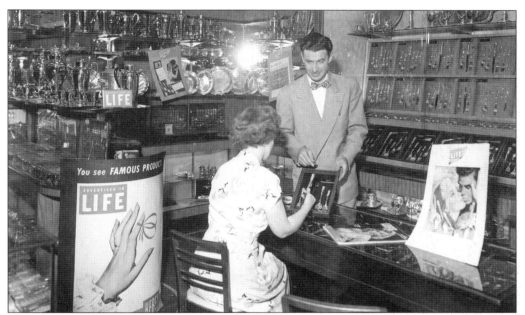

A SHOPPER PERUSES SILVERWARE, 1949. What makes this photo interesting is the advertisements for *LIFE* magazine. This appears to be a reciprocal relationship, where the retailers are rewarded for advertising the magazine in the store. There are several ads for *LIFE*, including a display of one of the magazines itself. The man presenting the silver flatware was Gordon Bier. (Photo courtesy of Mrs. Frances Kernis and son, Mr. Jeffery Kernis.)

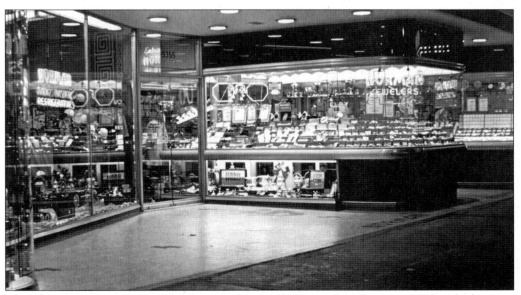

NORMAN JEWELERS, C. 1950S. Many employees of Norman Jewelers remained with the store for years. They acquired great skills and expertise in the field of jewelry retailing, and some took this knowledge and advanced in jewelry-related fields. Robert Pliskin, one of these employees, eventually became president of the Longine-Wittanaur Watch Company. (Photo courtesy of Mrs. Frances Kernis and son, Mr. Jeffery Kernis.)

	Motley, Willard F.		Single		ACCT. NO. 101

ACCOUNT RECORD OF WILLARD MOTLEY AT NORMAN JEWELERS. Norman Jewelers was one of the stores that encouraged African-American patronage. Willard Motley opened up one of the very first accounts with the store. He was born on July 14, 1912, and was the nephew of famous artist Archibald Motley Jr. He grew up in Englewood in one of the few African-American households at the time. As a writer, he wanted his work to focus on the reality of life in urban dwellings, thus he moved form his middle-class home in Englewood to Maxwell Street, Chicago's famous open-market. Within the milieu of Maxwell Street, Motley experienced the realities of Chicago's struggling immigration population. It was through his observational experiences on Maxwell Street that he wrote the novel *Knock on Any Door*, in 1947, which underscores the reality of street life. The book was later made into a movie that starred Humphrey

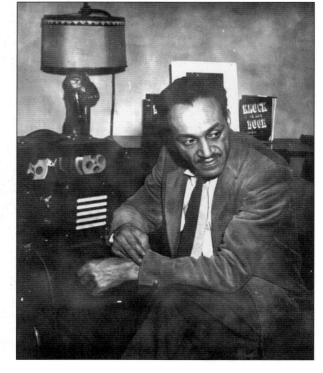

Bogart and was released in 1949. When Motley opened his account, he lived in Englewood. By 1947, he had moved into the area of Old Town. During the 1940s and 1950s, the area was considered the "Greenwich Village" of Chicago, because a concentration of radio and theatre personalities had moved in. Also, at that time, residents of the area on Wells Street faced urban realities that many also faced living near Maxwell Street. (Photo courtesy of Mrs. Frances Kernis and son, Mr. Jeffery Kernis.)

WILLARD MOTLEY. (Photo courtesy of NIU's Special Collections.)

CONTEST WINNERS, NORMAN HOME APPLIANCE STORE, 1958. Kernis often sponsored promotional events and give-aways to residents. This couple received a record player in one of the events. This photograph highlights that the ethnic residential background of Englewood was shifting, as middle-class African-American families started moving into the neighborhood. The salesperson is Norman's brother Alvin, with wife, Esther, off to the right. (Photo courtesy of Mrs. Frances Kernis and son, Mr. Jeffery Kernis.)

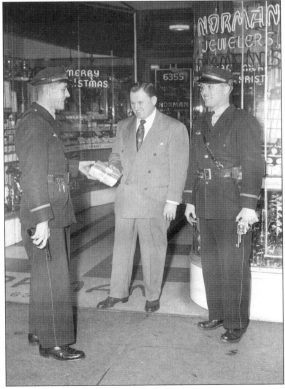

NORMAN KERNIS WITH SPECIAL POLICE OFFICERS, CHRISTMAS SEASON, C. 1949. This humorous take indicates the levity and strong relationship between store owners and the local police department. (Photo courtesy of Mrs. Frances Kernis and son, Mr. Jeffery Kernis.)

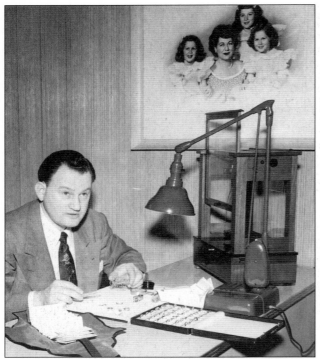

NORMAN KERNIS, C. 1945. This image of Norman working has a portrait photograph of Frances Kernis and their three daughters in the background (their son Jeffery was born in 1949). Frances worked with Norman in many capacities from 1939 to 1988, from selling to managing. Once a week, Frances would bring her children to work to help them understand the family business. Norman had a profound effect on the Englewood's business community. He served twice as president of the Englewood Business Men's Association, chairman of the Southtown Planning Committee, a director and treasurer of St. Bernard's Hospital, and was appointed by Mayor Richard J. Daley to chair the management of the Englewood Mall. (Photo courtesy of Mrs. Frances Kernis and son, Mr. Jeffery Kernis.)

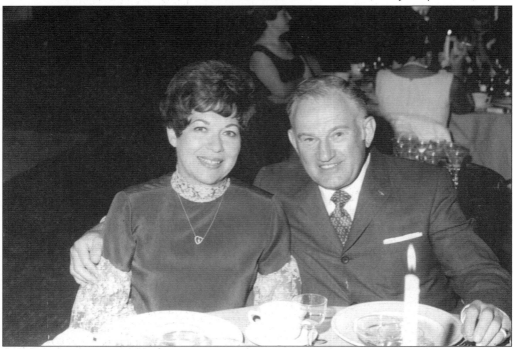

FRANCES AND NORMAN KERNIS, MARCH 2, 1969. The couple is pictured here attending a dinner and dance function at Temple Anshe Shalom. (Photo courtesy of Mrs. Frances Kernis and son, Mr. Jeffery Kernis.)

JOSIE AND JOE WALSH. Joe and Josie Walsh owned the Marine Tap. Located near 64th, off Halsted Street, it provided respite for many salespeople working in the retail stores and became a popular entity. (Photo courtesy of Dr. Irving A. Kernis.)

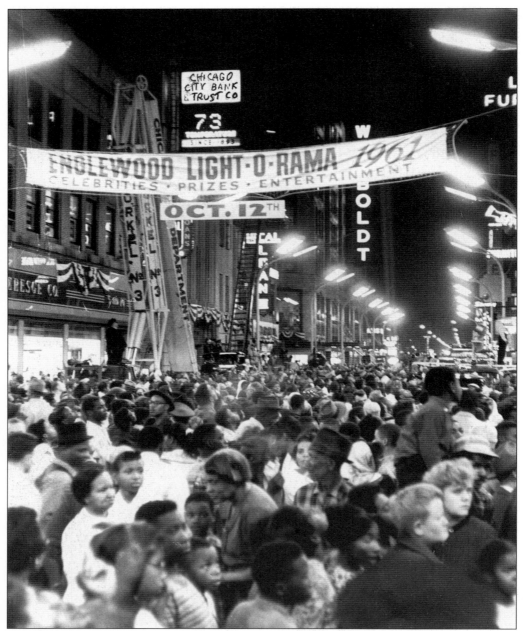

ENGLEWOOD LIGHT-O-RAMA FESTIVAL, LOOKING WEST FROM 63RD AND HALSTED STREETS, 1961. This community-based festival was located in the heart of the commercial center. In 1961, Englewood was a neighborhood in transition. Demographics and economics changed as many city residents moved to the suburbs. Additionally, the community, specifically the commercial district, was about to embark on a new system of urban renewal. (Photo courtesy of Pullman Bank and Trust.)

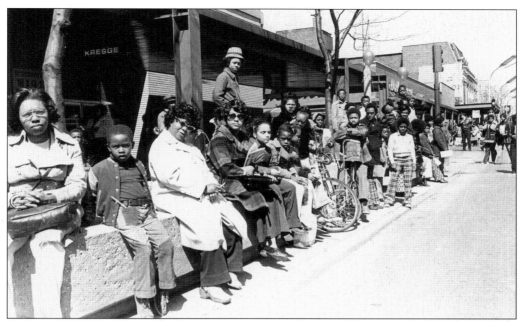

ENGLEWOOD EASTER PARADE, 1975. The composition of the commercial strip had changed by this time. Street canopies line the streets, which was one of the urban renewal changes that occurred in the mid-1960s. Street traffic was also re-routed and Halsted Street became a pedestrian mall to compete with the modern malls of the surrounding areas. (Photo courtesy of the Englewood Business Men's Association.)

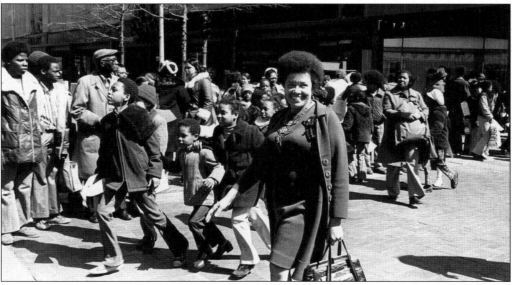

ENGLEWOOD EASTER PARADE, 1975. This photo sums up the spirit of the Easter Parade. People appear to be having fun, providing another opportunity for the community to take part in the shopping district festivities. Pictured center, Anna Langford, Englewood alderman from 1971-1974 and 1983-1991, walks in the parade. (Photo courtesy of the Englewood Business Men's Association.)

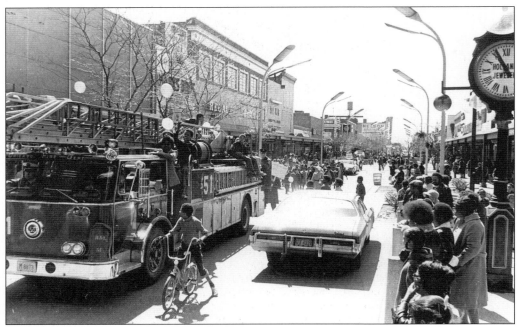

ENGLEWOOD EASTER PARADE, 1975. The Englewood Business Men's Association sponsored the annual Easter and Christmas Parades. (Photo courtesy of the Englewood Business Men's Association.)

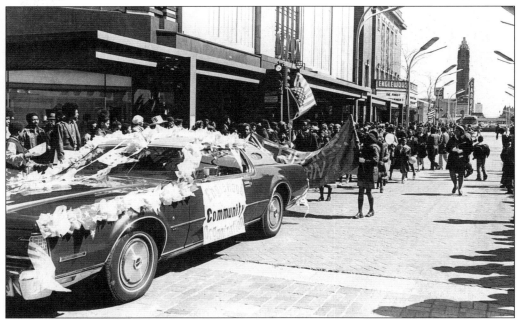

ENGLEWOOD EASTER PARADE, 1975. Residents march in the parade. The Englewood Theatre and Carr's Department Store are pictured in the background. Carr's bought the land and theater that originally comprised the Southtown Theatre. (Photo courtesy of Mrs. Frances Kernis and son, Mr. Jeffery Kernis.)

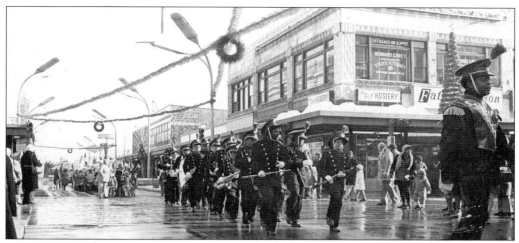

CHRISTMAS PARADE, 63RD STREET LOOKING EAST, 1977. Residents enjoyed the festivities of the holiday season. State's Attorney Bernard Carey kept his office in the corner building of Halsted and 63rd Streets. Many local politicians' offices were located in the center of Englewood, including former Alderman and State Sen. Charlie Chew. Chew's flamboyant style often attracted the attention of the media, however he is fondly remembered by Englewood residents, past and present, for his commitment to the community. (Photo courtesy of Mrs. Frances Kernis and son, Mr. Jeffery Kernis.)

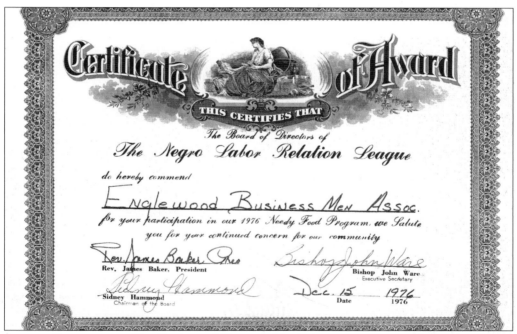

AWARD CERTIFICATE. The Englewood Business Men's Association received this award from the Negro Labor Relation League in 1976 for their participation in the Needy Food Program. One of the tenets of the association is to take part and contribute to causes. This tradition is still a strong part of the ideals of the organization. (Photo courtesy of the Englewood Business Men's Association.)

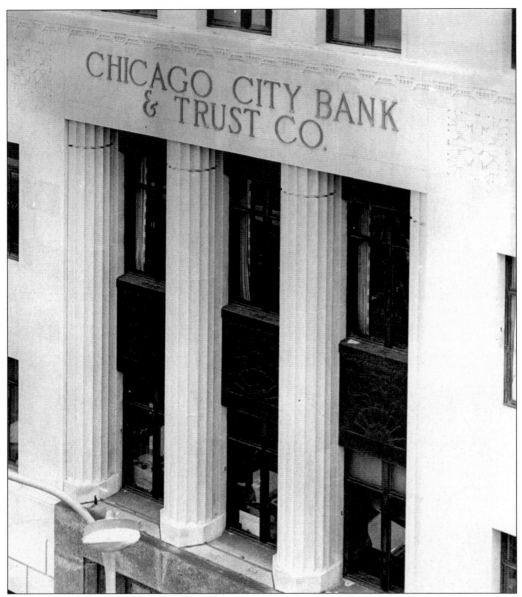

COMPLETED CHICAGO CITY BANK BUILDING, JANUARY 1930. The building, considered an architectural gem of Englewood, boasts an art-deco design popular at the time of its construction. The Chicago City Bank & Trust was one of the largest banks in Englewood, and as Pullman Bank and Trust today, it remains one of the very few left to serve area residents. Through staff and hired photographers, the bank documented the businesses in Englewood's commercial district. The bank's investments went beyond a monetary value. It took part in neighborhood celebrations and its presidents served on important committees in the ensuing years, including the Englewood Business Men's Association and on conservation and urban renewal planning committees. Pullman Bank and Trust bought out the bank in 1999. The new bank continues to follow the tradition of the Chicago City Bank & Trust by supporting the community through a myriad of activities and commitments to area residents. (Photo courtesy of Pullman Bank and Trust.)

6225 S. HALSTED STREET, 1893. Chicago City Bank constructed its first building at the northeast corner of Halsted and Englewood Streets. The surrounding area was not fully developed, yet the commercial center was about to gain in popularity. The elevated line already extended into Englewood, and the World's Columbian Exposition brought many people to the community to visit, lodge, shop, and dine. (Photo courtesy of Pullman Bank and Trust.)

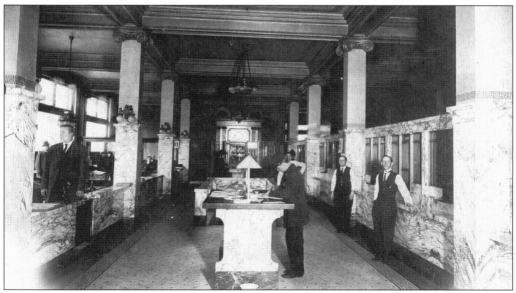

LOBBY INTERIOR OF CHICAGO CITY BANK, SECOND BANK LOCATION, 6233–35 S. HALSTED, 1910. As the bank's services and customer base expanded, so did its need to find a larger space. The growth of the community fostered the need for larger financial institutions. There would be one more move, into a larger, permanent space that would serve the bank and community into the present. The bank acquired trust status in 1912 to better serve their growing clientele and changed it name to Chicago City Bank & Trust. (Photo courtesy of Pullman Bank and Trust.)

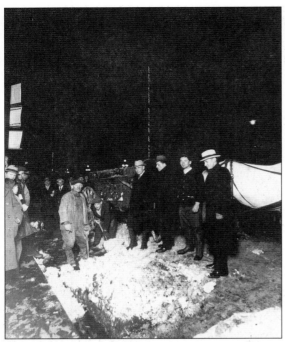

SITE FOR THE THIRD BANK BUILDING, 815 W. 63RD STREET, 1929. Snow is removed from the ground on which the building was to be built. Pictured here, from left to right are Frank G. Rathje, the second bank president in the bank's history; Leonard Fish, president of the Englewood Business Men's Association; Mr. Sievers; and William G. Doone. (Photo courtesy of Pullman Bank and Trust.)

CORNERSTONE CEREMONY OF THE CHICAGO CITY BANK BUILDING, AUGUST 13, 1929. (Photo courtesy of Pullman Bank and Trust.)

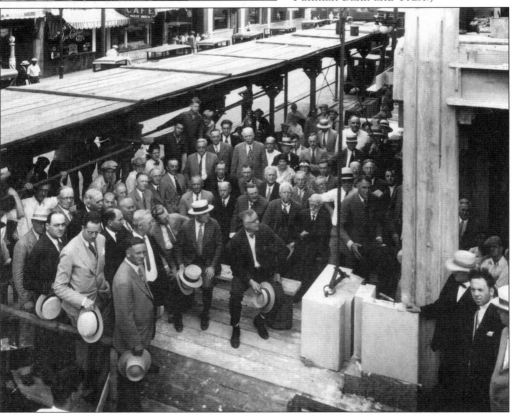

FRANK G. RATHJE, PRESIDENT, PLACES BOX OF ARTIFACTS INTO THE BUILDING'S CORNERSTONE. (Photo courtesy of Pullman Bank and Trust.)

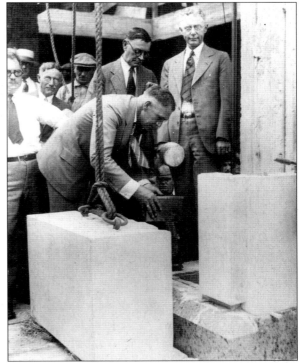

MID-STAGE CONSTRUCTION OF THE BANK, SEPTEMBER 28, 1929. A. Epstein served as the architect and Dilks Construction Company built the structure. (Photo courtesy of Pullman Bank and Trust.)

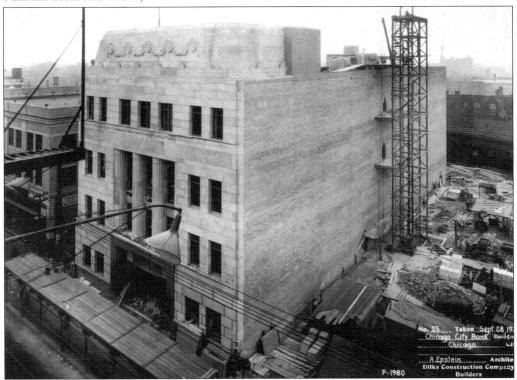

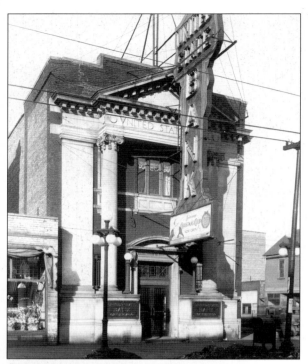

UNITED STATES BANK, 60TH AND HALSTED STREETS, FEBRUARY 1930. The United States Bank merged with Chicago City Bank. This site later became the Edwards and Mulder Funeral Home in the 1940s. (Photo courtesy of Pullman Bank and Trust.)

CHICAGO CITY BANK DRIVE-UP WINDOW, 1939. The bank was the first in the Chicago area to install a drive-in unit, thus highlighting the bank's pioneering methods of business. (Photo courtesy of Pullman Bank and Trust.)

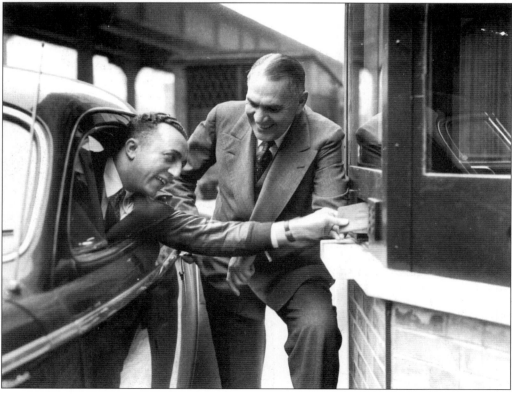

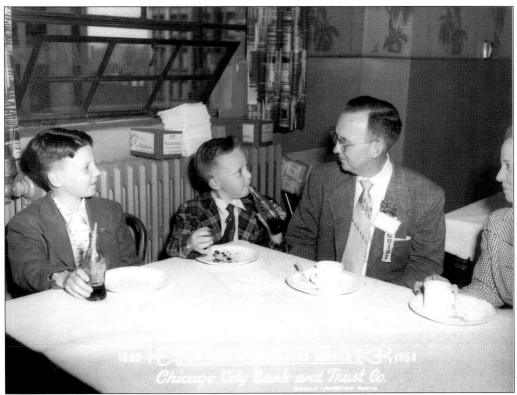

PROMOTIONAL PHOTOGRAPH, 50TH ANNIVERSARY, 1953. Pictured are Mr. and Mrs. Leslie Newgren and sons. Mr. Newgren was in charge of the bank's credit department. (Photo courtesy of Pullman Bank and Trust.)

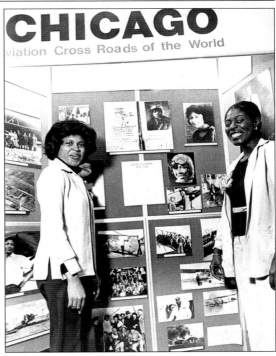

BLACK HISTORY MONTH EXHIBITION, FEBRUARY 1980. This exhibition at the bank celebrated the culture and contributions of African Americans. African-American history month started taking hold in the early 1980s, with the bank taking part in the important annual event. Chicago City Bank & Trust was often at the forefront of educational opportunities within the community. (Photo courtesy of Pullman Bank and Trust.)

OFFICE OF THE MAYOR
CITY OF CHICAGO

RICHARD J. DALEY
MAYOR

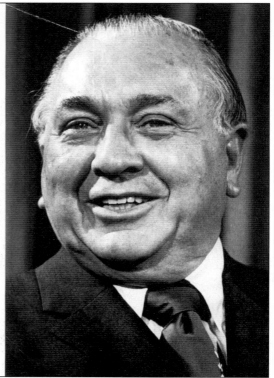

October 6, 1976

Gentlemen:

The Chicago City Bank and Trust Company continues
to provide highly important services for people throughout
the South Side and the entire Chicago area. The role of
Chicago City Bank has been of tremendous value to the
commercial and residential life of the Englewood Community.

I am very happy to take part in your "Time Capsule
1976-2076" project.

Everyone associated with Chicago City Bank has my
very best wishes for continuing success.

With warmest personal regards,

Mayor

"Time Capsule 1976-2076" Committee
Chicago City Bank and Trust Company
815 West 63rd Street
Chicago, Illinois 60621

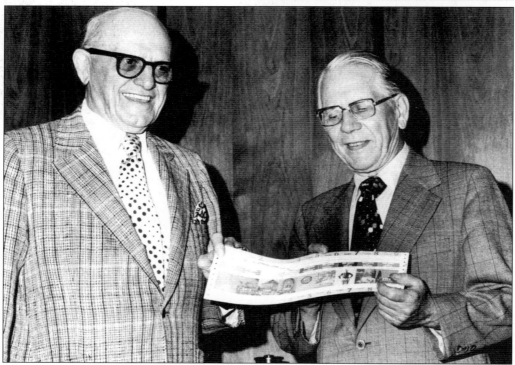

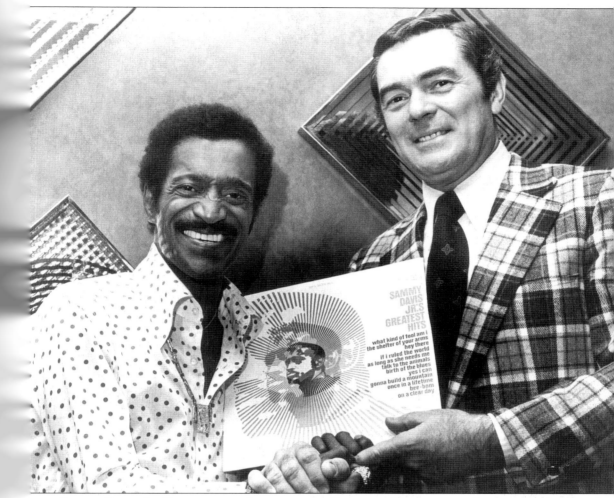

SAMMY DAVIS JR. PRESENTS AN ALBUM OF HIS GREATEST HITS FOR THE SPECIAL PROJECT "TIME CAPSULE 1976–2076", 1976. Bank president Gavin Weir Sr. accepts an artifact for the capsule. Weir was bank president at the time, and when Pullman acquired the bank, he stayed on as a senior consultant.

In 1976, the year of our country's bicentennial, many businesses and schools were creating time capsules. The Chicago City Bank & Trust was one organization taking part in the spirit. The bank asked businesses and celebrities to donate materials for the capsule, an important event for the Chicago City Bank & Trust. (Photo courtesy of Mr. Gavin Weir Sr.)

Opposite, Top: **LETTER FROM RICHARD J. DALEY, OCTOBER 6, 1976.** The mayor agreed to support the bank's "Time Capsule 1976–2076" project. One of the artifacts is a letter from Mayor Daley addressing Chicago citizens in 2076. (Photo courtesy of Pullman Bank and Trust.)

Opposite, Bottom: **PAPA BEAR, GEORGE S. HALAS, 1976.** Halas, president and chairman of the board of directors of the Chicago Bears Football Team presents Stanley Swanson, vice president of the bank, a complete sheet of the team's 1976 tickets for inclusion in the time capsule. (Photo courtesy of Mr. Gavin Weir Sr.)

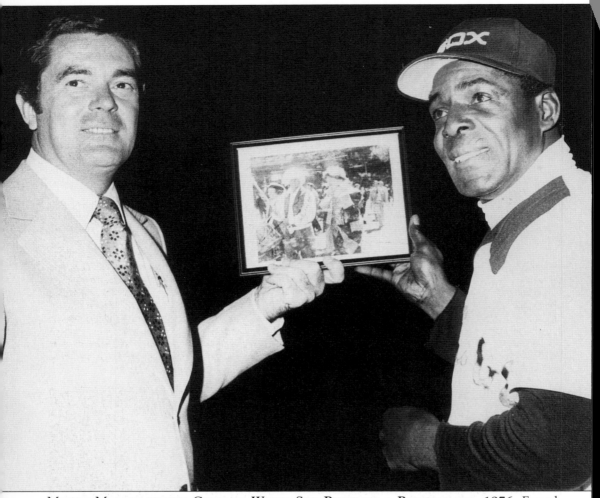

MINNIE MINOSO OF THE CHICAGO WHITE SOX PRESENTS A PHOTOGRAPH, 1976. Famed baseball player Minoso presents a photograph of the White Sox's 1976 opening day celebration for the time capsule. This sampling shows national and local stars contributing to the spirit of the bicentennial, and placing Chicago within the context of national history. (Photo courtesy of Mr. Gavin Weir Sr.)

Four
A CHANGING
NEIGHBORHOOD

After World War II, the ethnicity of the community started shifting as more African Americans began moving into the neighborhood. Additionally, workers from the stockyards looking for nearby affordable housing moved in more rapidly, significantly changing the social make-up of the community. This movement brought diversity to the population, and during the 1940s and 1950s, the transformation helped to characterize a neighborhood in flux. The immigrant population declined, yet during the 1940s and 1950s, the neighborhood remained predominantly white. After the 1940s, however, the second wave of the great migration, the African-American movement from the south, started to impact Englewood. Many African Americans from the south settled into already overcrowded neighborhoods, prompting longer-term residents of these areas to move to other parts of the city, including Englewood. Although there had always been an African-American population in Englewood, it had remained steady up until this time. The exodus of ethnic whites from Englewood carried over into the next decade. With the population shift came the tensions usually associated with racial issues, and the South Side has often been a hotbed for racial tension. Like the residents of the past, Englewood's new community members took pride in their neighborhood. Richard Stamz, co-author and former radio personality, moved into the neighborhood just prior to WWII and has documented some of the history related to the changes in the community.

1ST BATTALION, 8TH REGIMENT HEADQUARTERS COMPANY, C. 1939. This photo was taken at Camp Grant in Rockford while on a training exercise. The 8th Regiment was based at the 3500 block of South Giles, which is now a military training school. As one of the all-black regiments in the country, the 8th Regiment drew from all over Chicago's South Side, including Englewood. The soldier in the first row, fourth person from the left, is Richard Stamz. (Photo courtesy of Richard Stamz.)

BEALE SCHOOL, 1941–1945. (Photo courtesy of Special Collections and Preservation Division, Chicago Public Library.)

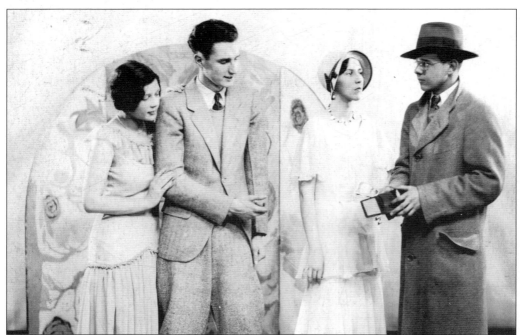

SCHOOL PLAY PHOTO, SCHOOL UNKNOWN, C. 1945. Many schools staged plays as extracurricular activities. This photo helps to identify the era in which the play takes place: the 1920s. (Photo courtesy of Special Collections and Preservation Division, Chicago Public Library.)

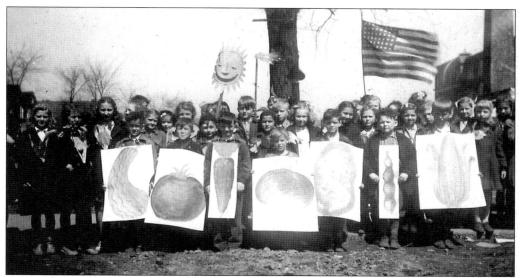

WENTWORTH ELEMENTARY SCHOOL, FLAG RAISING CEREMONY, C. 1941–45. Children take part in patriotic activities. (Photo courtesy of Special Collections and Preservation Division, Chicago Public Library.)

WENTWORTH SCHOOL, CLASS OF 1948. Anna Jean Clark, pictured third row from the front, fourth person from the right, graduated from Wentworth and continued her high school education at Parker. Anna is also Irving and Jewel Kernis's daughter. Irving A. Kernis was the brother of Norman Kernis, who owned Norman Jewelers in the shopping district. (Photo courtesy of Dr. Irving A. Kernis.)

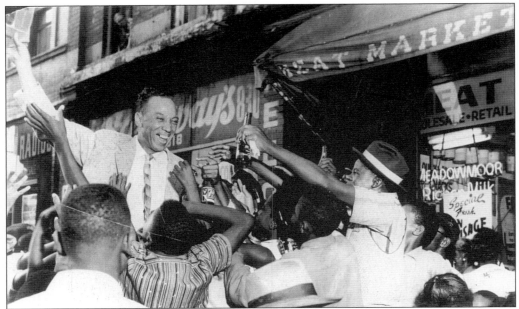

RICHARD STAMZ, CROWN PRINCE OF DISC JOCKEYS, C. 1956. This promotional image of Richard Stamz helps to link him as a significant player in the history of black radio in Chicago. His show, *Open the Door Richard*, on WGES helped to establish blues music in Chicago. Richard played a variety of artists that later became popular with both black and white audiences. The show aired weekdays at noon. Richard Stamz has lived in Englewood for over 60 years. He is currently 96 years old. (Photo courtesy of Richard Stamz.)

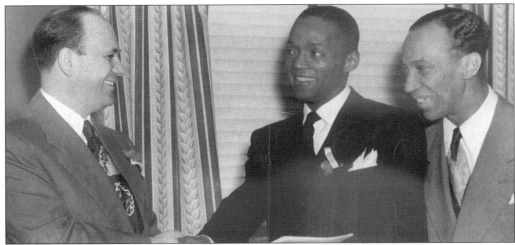

RICHARD STAMZ, GOVERNMENT INSPECTOR. Stamz, pictured on the right, was inducted as the first black member of the State of Illinois Factory Inspectors. Stamz took on many roles during his lifetime. From entertainer to government inspector, he has always taken pride in his work. Although he retired from the professional world in the 1960s, Richard continues to appear at social, educational, and community functions. Pictured here, from left to right, are the director of the Illinois Department of Labor at the time, Frank Annuzio (who later became a state representative), an unidentified man, and Richard Stamz. (Photo courtesy of Richard Stamz.)

THE GREEN DOOR NIGHTCLUB, C. 1959. Richard Stamz was co-owner of this establishment. This photo shows Richard with a few of the club's guests. Although entertainment in the Englewood neighborhood was vital to the community culture, the Green Door was highly controversial. Some residents in the community did not want a black-owned nightclub in the vicinity and after two-and-a-half years, it finally closed down. Stamz's connection to the entertainment industry brought a number of blues players, including Willie Dixon and Howlin' Wolf, to the Green Door. (Photos courtesy of Richard Stamz.)

THE GREEN DOOR, C. 1959. A band plays for the crowd.

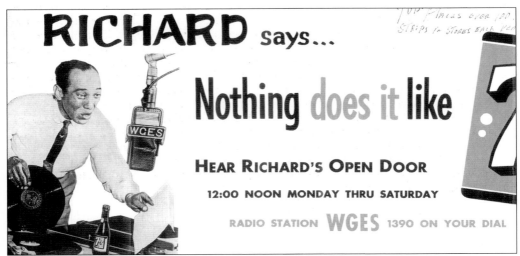

PROMOTIONAL ADVERTISEMENT, 7-UP, C. 1952. One of Stamz's first and most prominent sponsors was 7-Up, for which Richard helped to establish a consumer market in the African-American community. (Photo courtesy of Richard Stamz.)

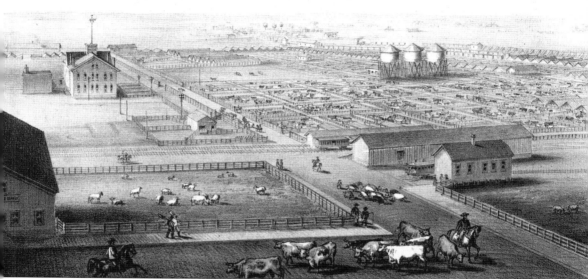

DRAWING OF THE UNION STOCKYARDS, 1866. This drawing by Louis Kurz and published by Jerne and Almini, depicts the Chicago Union Stockyards the year after they opened. Before the stockyards, the meat trade industry in Chicago was scattered and inefficient. Fostered by the need to provide provisions for the Union Army during the Civil War, Chicago surpassed Cincinnati as the largest meat-packer in the world. Given the size of the industry and the need to create a working system, 320 acres just outside the city limits on the South Side, in the Town of Lake, was designated for the stockyards, between 39th and 47th Streets, and Halsted and what is now Racine Avenue. The land just west of that was used by the packinghouses. The success of the stockyards was financially supported by nine railroads and engineered by the already existing slaughtering and meatpacking businesses, including the Chicago Pork Packers' Association. The Union Stockyards sought to consolidate the efforts of the meat trade industry with such companies as Swift and Armour. Although other cities had strong meat industries, it was the centralized location of the railroads, the use of refrigerated rail cars, and the business plan of the Union Stockyards that helped to make them extremely successful. (Photo courtesy of the Chicago Historical Society.)

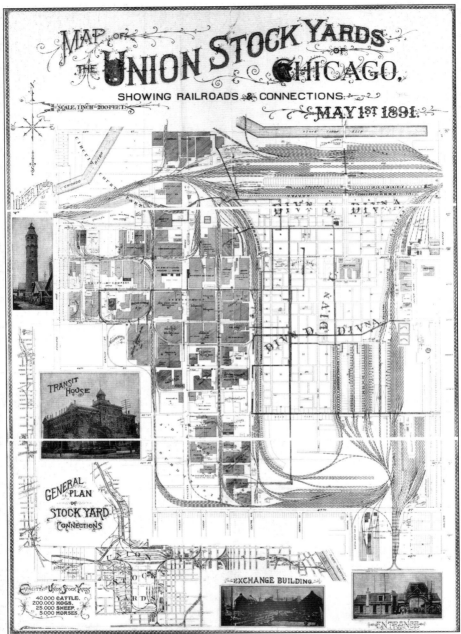

MAP OF THE UNION STOCKYARDS, 1891. The stockyards proved to be not only successful, but incredibly efficient. This map helps to show the scale and size of the industry. It shows the pen capacity of cattle, hogs, sheep, and horses, at least double in size from when it first opened on Christmas Day, 1865. Because of the industry, many communities started to sprout up around the area. Various immigrant populations held many of the labor jobs. With the establishment of communities came the churches and congregations. The Back-of-the-Yards, however, had always been a less economically viable community. Many workers struggled to move into safer and more established neighborhoods like Englewood. (Photo courtesy of the Chicago Historical Society.)

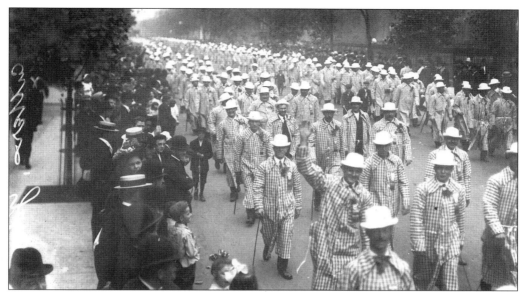

LABOR DAY PARADE, MEAT CUTTERS, 1908. As the industry grew, so did the labor movement. Although businesses prospered, workers faced unsanitary and difficult conditions. Upton Sinclair, author of *The Jungle*, helped to solidify the rough existence of the industry workers. What resulted, after years of struggle, was the unionization of workers. (Photo courtesy of the Chicago Historical Society.)

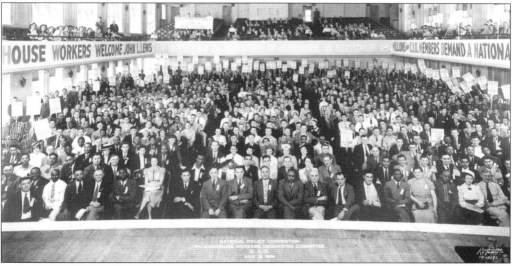

PACKINGHOUSE WORKERS' ORGANIZING COMMITTEE, NATIONAL POLICY CONVENTION, JULY 16, 1939. In the 1930s, unions became strong entities, greatly increasing in numbers. Union Stockyard workers took advantage of collective bargaining by participating in their unions. But African-American workers were often shut-out of the union process early on. As the years went by, the ethnicity of unions shifted. The work of the laborers was hard, and second-generation immigrant groups chose to move on to other areas of business. Many African Americans filled the positions and moved into the surrounding neighborhoods. (Photo courtesy of the Chicago Historical Society.)

UNION RALLY, 61ST AND RACINE, C. 1950. The following three images offer a panoramic view of this rally in support of union workers. Community members listened to a speech given by the president of the Stockyard Union. A police station was built on this spot in 1954. (Photos courtesy of Richard Stamz.)

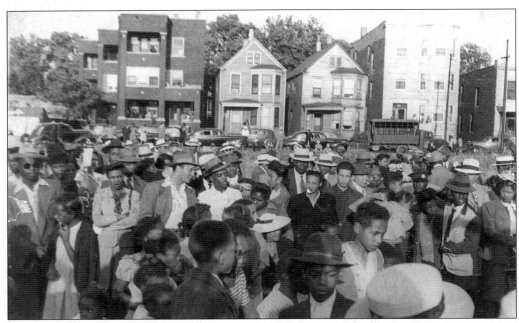

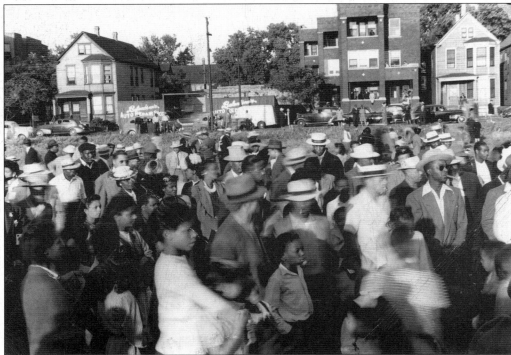

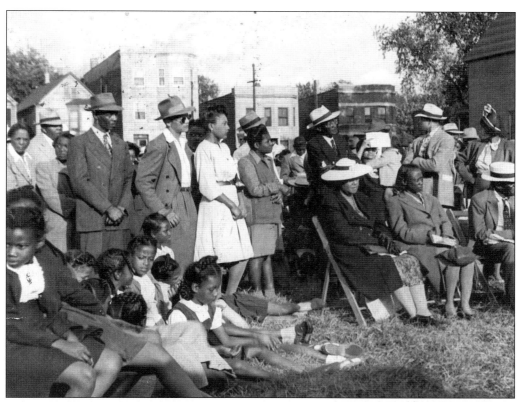

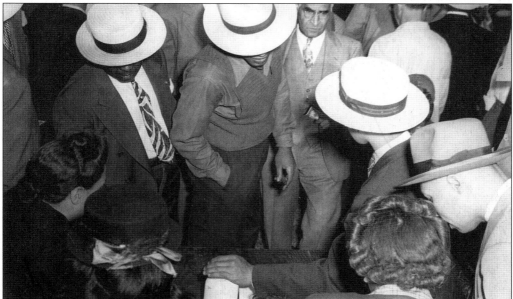

UNION RALLY, 61ST AND RACINE, C. 1950. At the same rally, the Red Caps Union president, associated with the Brotherhood of Sleeping Car Porters Union, is registering names in protest of the mistreatment of Chicago Union Stockyard workers. (Photo courtesy of Richard Stamz.)

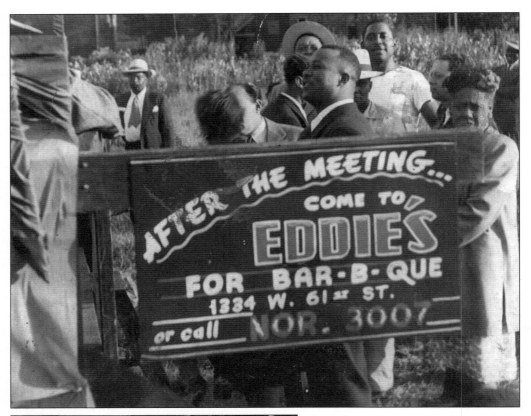

EDDIE'S RESTAURANT, UNION RALLY, 61ST AND RACINE, C. 1950. Eddie's Restaurant offered people a chance to eat and discuss the gathering. Additionally, the restaurant was able to advertise to a large audience at one time. (Photo courtesy of Richard Stamz.)

COLLAGE OF MURPHY FAMILY PHOTOGRAPHS FROM 1940 TO 1985. This collage of one of Englewood's families shows its members through the middle of the 20th century. (Photo courtesy of Richard Stamz.)

Five

URBAN RENEWAL
AND CONSERVATION

As Englewood's housing stock deteriorated, urban renewal and conservation money was assigned to the community. Conservation involves restoration of already existing housing and buildings as well as beautification of the area. Conservation plans took hold primarily in the 1950s. But the goal of urban renewal was to increase the economic viability of the land, ultimately raising property values for residents and increasing taxes for the city. Urban renewal entailed the clearing of land to re-develop, thus depleting an area of deteriorating buildings. The city had wide-sweeping plans for some large areas in Chicago, including Englewood. Issues surrounding urban renewal were controversial and Englewood residents battled on both sides of the issue for decades. One of the most prominent urban renewal projects involved the remodeling of the central commercial district. As people moved out of the neighborhood, and new shopping malls were developed in the 1960s, the shopping district became less of a destination and its profitability altered greatly. In the early 1960s, the City of Chicago, working alongside businesses, developed a plan to change the nature of the commercial strip itself. Given the success of the new trend in shopping malls across the country and the increasing competition from South Side area malls including Evergreen Plaza and Ford City, the Englewood Shopping District was redesigned into a pedestrian mall. Titled Ill.R-47, the plan designated new automobile roadways that went around the newly revamped center, additional parking, and new canopies for the stores. This was done at the cost of displacing about 400–600 residents, specifically on Green Street, just west of Halsted Street. The purpose of the plan was to revitalize the shopping district and to keep current retailers in the neighborhood. Completed in 1969, this plan focused on a commercial strip rather than a residential area, one of the first of its kind nationally. Although ambitious, the new mall did not bring in consumers and the commercial district's revenues continued to decline. In 1988, under Mayor Eugene Sawyer, the pedestrian mall was removed through a new Englewood Plan, making way for traffic once again.

DAN RYAN EXPRESSWAY, 1964. The Dan Ryan Expressway was a major project that connected the South Side and the suburbs to the downtown area and other expressways. One of the world's widest expressways, it has a "dual-dual" system, which incorporates local and express travel, an innovation at the time. However, the project was a major source of contention with residents in the South Side African-American community. Displacing hundreds of people, it also coincided with the development of the Robert Taylor Homes—public housing that was controversial because it essentially confined and constricted the residents to an otherwise isolated strip of land, leaving little room for the development of businesses and social organizations. Despite its advantage to communities and suburbs on the South Side, the Dan Ryan created a dividing line between black and white communities. (Photo courtesy of the Chicago Historical Society.)

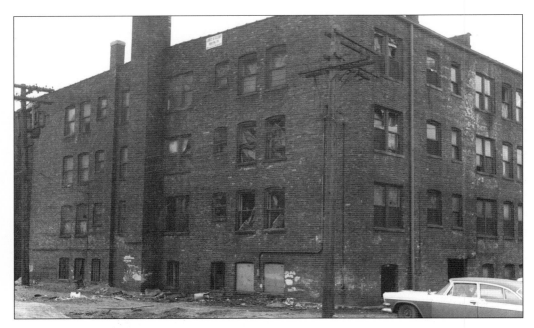

6425–33 S. Yale. c. 1962. These images relate to conservation and rehabilitation of a condemned apartment building. The picture above shows the "before" view and below, the "after." South Side real estate company Mckey & Poague, Inc. rehabbed the building. Through the neglect of buildings and slipping property values, it became difficult for landlords to maintain buildings. Private investment was one way to improve buildings that had deteriorated. This was just one project in a trend employed to renovate buildings. (Photos courtesy of the Englewood Business Men's Association.)

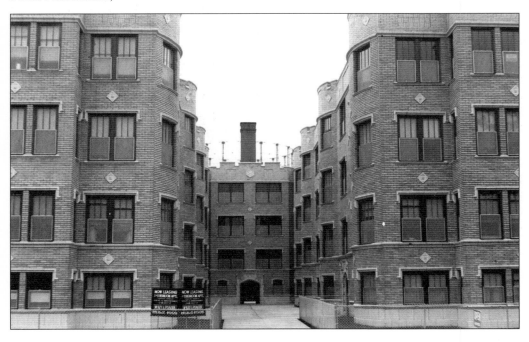

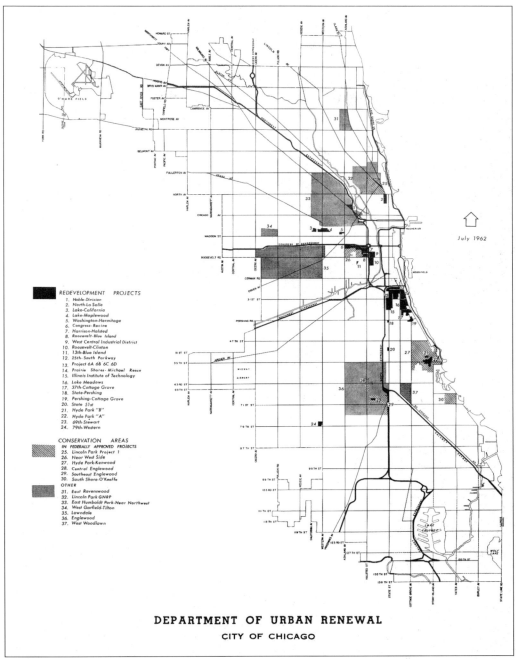

REDEVELOPMENT PROJECTS
1. Noble-Division
2. North-La Salle
3. Lake-California
4. Lake-Maplewood
5. Washington-Hermitage
6. Congress-Racine
7. Harrison-Halsted
8. Roosevelt-Blue Island
9. West Central Industrial District
10. Roosevelt-Clinton
11. 13th-Blue Island
12. 25th-South Parkway
13. Project 6A 6B 6C 6D
14. Prairie Shores- Michael Reese
15. Illinois Institute of Technology
16. Lake Meadows
17. 37th-Cottage Grove
18. State-Pershing
19. Pershing-Cottage Grove
20. State 51st
21. Hyde Park "B"
22. Hyde Park "A"
23. 60th-Stewart
24. 79th-Western

CONSERVATION AREAS
IN FEDERALLY APPROVED PROJECTS
25. Lincoln Park Project 1
26. Near West Side
27. Hyde Park-Kenwood
28. Central Englewood
29. Southeast Englewood
30. South Shore-O'Keeffe
OTHER
31. East Ravenswood
32. Lincoln Park GNRP
33. East Humboldt Park-Near Northwest
34. West Garfield-Tilton
35. Lawndale
36. Englewood
37. West Woodlawn

July 1962

DEPARTMENT OF URBAN RENEWAL
CITY OF CHICAGO

MAP OF CITY'S URBAN RENEWAL SECTIONS, 1962. This map helps to locate redevelopment and conservation areas. Some of the conservation areas were federally approved, indicating that federal funds would supplement the city's efforts. (Photo courtesy of the Englewood Business Men's Association.)

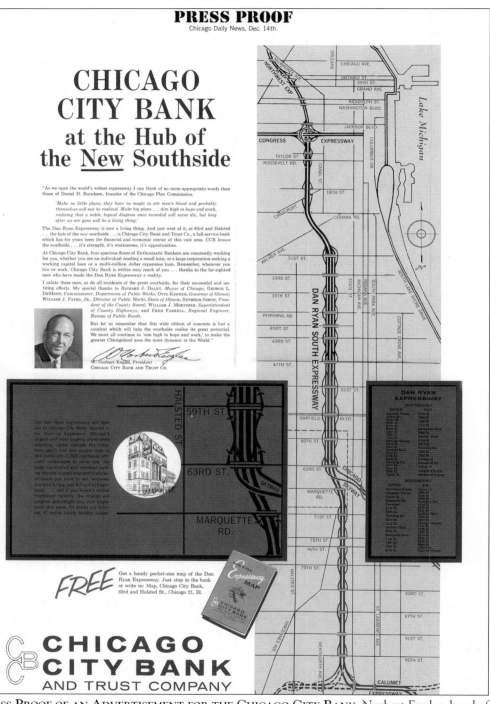

PRESS PROOF OF AN ADVERTISEMENT FOR THE CHICAGO CITY BANK. Norbert Engles, head of the Englewood Business Men's Association during the 1960s, and president of the Chicago City Bank & Trust, encourages banking and shopping via the new expressway. (Photo courtesy of the Englewood Business Men's Association.)

E ENGLEWOOD
Christian Leadership Conference

L 6409 SOUTH SANGAMON ST.
CHICAGO, ILLINOIS 60621
C TELEPHONE: TR 3-3993

Dr. MARTIN LUTHER KING, Jr., President

Rev. JOHN R. PORTER, Local President

Mr. Norbert Engles, President
Chicago City Bank
63rd Street at Halsted
Chicago Illinois, 60621

Dear Mr. Engles:

Our investigation of the "Proposed Housing Project For The Aged" at 6500 South Union and Lowe Streets, have revealed that the local neighborhood involved is totally uninformed of the proposals. This has instilled personal and group fear, anxiety, and panic; violating both moral and human rights of citizens. We believe enough money is available to finance a better program.

We would like to use the Democratic process of sitting down to discuss this matter with you. We suggest that you or representatives from your office meet with us at the Southtown YMCA, 6500 South Union, on Friday, Aug. 28 at 7:30 P. M.

We hope to hear from you before initiating any further action.

JRP: p

Mr. Alvin Rose
Committeeman Shannon
Alderman Charles Chew
Mr. Fred Henderson
Mr. Albert Raby
Mr. Henry Wilson
Mr. James Batts
Mrs. Bernice Mariner
Mr. John Duba
Mayor Richard H. Daley
Hon. Robert E. Weaver (telegram)

Sincerely,

Rev. John R. Porter,
President

Mrs. Dorothy H. Edwards,
Acting Housing Chrm.

LETTER FROM THE ENGLEWOOD CHRISTIAN LEADERSHIP CONFERENCE (ECLC). In 1964, the Englewood Christian Leadership Conference sent a letter to Norbert Engles protesting a housing plan for community elders. Born in Georgia and later employed in Washington, Engles was hired to lead the bank and to help revitalize the shopping district. As president of the Englewood Business Men's Association, Engles focused on representing the commercial aspects of the community and sparking interest in the business district in order to keep it from becoming a second-rate shopping center. Engles also headed other organizations in relation to housing developments. The tactic that many community organizations took against urban renewal and development plans was to act within a democratic forum in order to present and discuss issues and ideas. This letter is in response to a proposed housing project for senior citizens and the lack of consultation with area residents. (Photo courtesy of the Englewood Business Men's Association.)

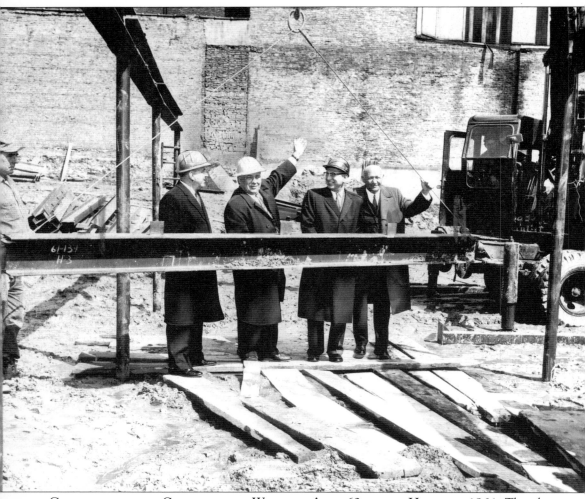

GROUND-BREAKING CEREMONY FOR WALGREEN'S AT 63RD AND HALSTED, 1961. The plans for the new mall were discussed early on and documents regarding the change started surfacing in the early-1960s. The new Walgreen's coincided with urban renewal planning, one of Mayor Daley's major projects to keep the city vital and modern. Walgreen's has been there since 1961 and is still there today. (Photo courtesy of the Chicago Historical Society.)

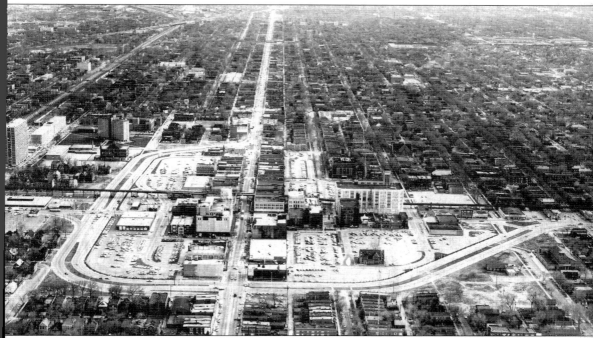

AERIAL VIEW OF ENGLEWOOD'S NEWLY REVAMPED SHOPPING DISTRICT, 1969. This image shows the final product of the urban renewal plan entitled Ill. R-47. The plan ultimately did not serve the needs of the residents and business community. (Photo courtesy of the Englewood Business Men's Association.)

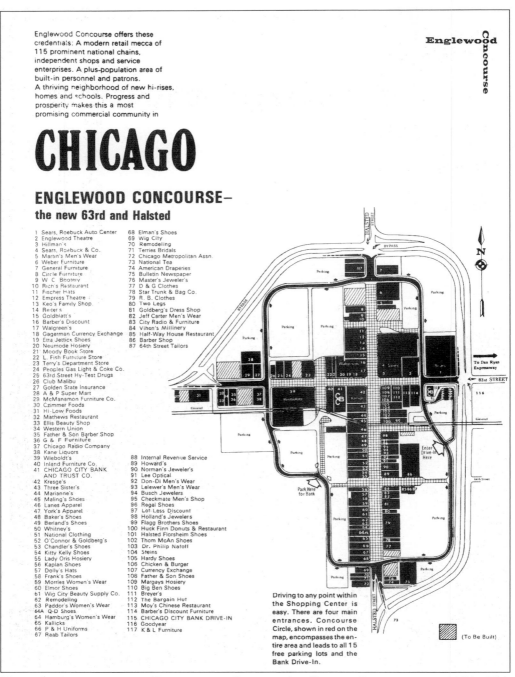

Englewood Concourse offers these credentials: A modern retail mecca of 115 prominent national chains, independent shops and service enterprises. A plus-population area of built-in personnel and patrons. A thriving neighborhood of new hi-rises, homes and schools. Progress and prosperity makes this a most promising commercial community in

CHICAGO

ENGLEWOOD CONCOURSE—
the new 63rd and Halsted

1 Sears, Roebuck Auto Center	68 Elman's Shoes
2 Englewood Theatre	69 Wig City
3 Hillman's	70 Remodeling
4 Sears, Roebuck & Co.	71 Terries Bridals
5 Martin's Men's Wear	72 Chicago Metropolitan Assn.
6 Weber Furniture	73 National Tea
7 General Furniture	74 American Draperies
8 Circle Furniture	75 Bulletin Newspaper
9 W. C. Brothru	76 Master's Jeweler's
10 Rich's Restaurant	77 D & G Clothes
11 Fischer Hats	78 Star Trunk & Bag Co.
12 Empress Theatre	79 R. B. Clothes
13 Keo's Family Shop	80 Two Legs
14 Reiter's	81 Goldberg's Dress Shop
15 Goldblatt's	82 Jeff Carter Men's Wear
16 Barber's Discount	83 City Radio & Furniture
17 Walgreen's	84 Vihon's Millinery
18 Gagerman Currency Exchange	85 Half-Way House Restaurant
19 Etta Jettick Shoes	86 Barber Shop
20 Neumode Hosiery	87 64th Street Tailors
21 Moody Book Store	
22 L. Fish Furniture Store	
23 Terry's Department Store	
24 Peoples Gas Light & Coke Co.	
25 63rd Street Hy-Test Drugs	
26 Club Malibu	
27 Golden State Insurance	
28 A & P Super Mart	
29 McManamon Furniture Co.	
30 Czimmer Foods	
31 Hi-Low Foods	
32 Mathews Restaurant	
33 Ellis Beauty Shop	
34 Western Union	
35 Father & Son Barber Shop	
36 G & F Furniture	
37 Chicago Radio Company	
38 Kane Liquors	
39 Wieboldt's	88 Internal Revenue Service
40 Inland Furniture Co.	89 Howard's
41 CHICAGO CITY BANK AND TRUST CO.	90 Norman's Jeweler's
	91 Lee Optical
42 Kresge's	92 Don-Di Men's Wear
43 Three Sister's	93 Lelewer's Men's Wear
44 Marianne's	94 Busch Jewelers
45 Maling's Shoes	95 Checkmate Men's Shop
46 Lanes Apparel	96 Regal Shoes
47 York's Apparel	97 Lot-Less Discount
48 Baker's Shoes	98 Holland's Jewelers
49 Berland's Shoes	99 Flagg Brothers Shoes
50 Whitney's	100 Huck Finn Donuts & Restaurant
51 National Clothing	101 Halsted Florsheim Shoes
52 O'Connor & Goldberg's	102 Thom McAn Shoes
53 Chandler's Shoes	103 Dr. Philip Natoff
54 Kitty Kelly Shoes	104 Steins
55 Lady Oris Hosiery	105 Hardy Shoes
56 Kaplan Shoes	106 Chicken & Burger
57 Dolly's Hats	107 Currency Exchange
58 Frank's Shoes	108 Father & Son Shoes
59 Morries Women's Wear	109 Margays Hosiery
60 Elmor Shoes	110 Big Ben Shoes
61 Wig City Beauty Supply Co.	111 Breyer's
62 Remodeling	112 The Bargain Hut
63 Paddor's Women's Wear	113 Moy's Chinese Restaurant
64A Q-D Shoes	114 Barber's Discount Furniture
64 Hamburg's Women's Wear	115 CHICAGO CITY BANK DRIVE-IN
65 Kallicks	116 Goodyear
66 P & H Uniforms	117 K & L Furniture
67 Raab Tailors	

Driving to any point within the Shopping Center is easy. There are four main entrances. Concourse Circle, shown in red on the map, encompasses the entire area and leads to all 15 free parking lots and the Bank Drive-In.

(To Be Built)

TWO ADVERTISEMENTS: ENGLEWOOD CONCOURSE RETAIL LISTINGS, C. 1970. The Englewood Business Men's Association always remained active in the promotion of the district. A marketing booklet from 1970 shows 117 stores in the shopping center. The diversity in stores alone attests to the significance of the district's commercial viability in earlier decades, but as

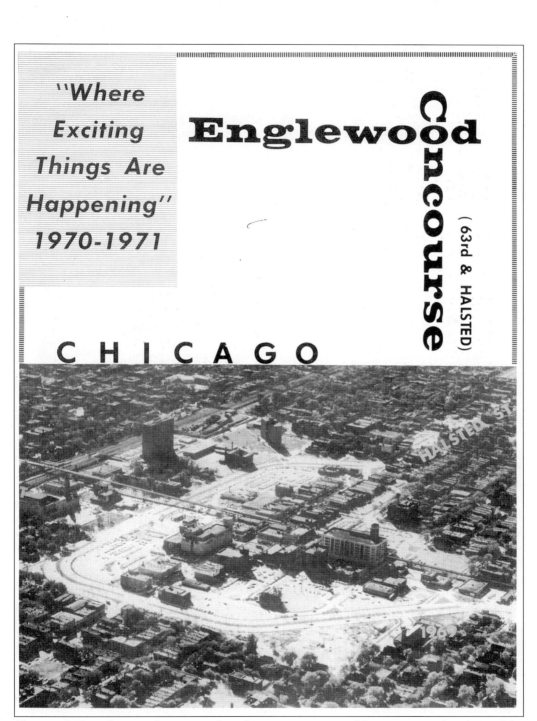

"Where Exciting Things Are Happening"
1970-1971

Englewood Concourse (63rd & HALSTED)

CHICAGO

Chicago dealt with general patterns of resident migration out of the area into other parts of the city or suburbs, stores also moved as they continued to show annual losses. (Photos courtesy of the Englewood Business Men's Association.)

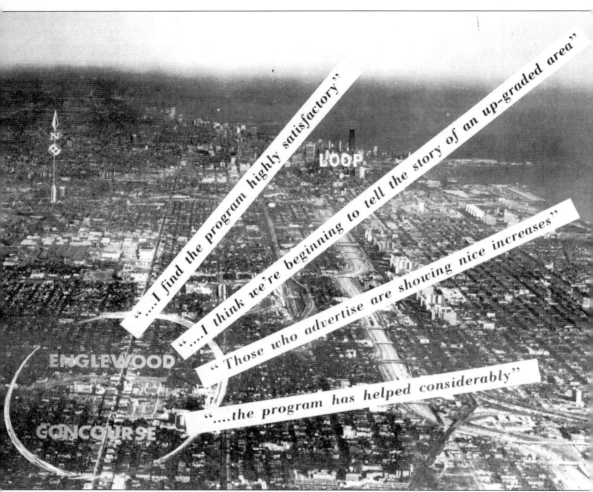

AERIAL VIEW OF CITY, C. 1970. This image highlights Englewood's presence in the city, and its proximity to the downtown area. (Photo courtesy of the Englewood Business Men's Association.)

Six

CONTEMPORARY TIMES

As cities across the United States revitalize, so does the Englewood community, despite its years of attempted urban renewal and economic shifts. Many residents take pride in their homes and community and battle daily to fight crime and other urban-related issues. Community organizations and churches are active in fostering a vision for Englewood. James Stampley, author of Challenges and Changes: A Documentary of Englewood *(1979), encourages residents to take political and social action to improve the community. He still resides in Englewood and helps to keep issues in the forefront. In 1999, the city announced plans to demolish the remaining shopping district and move Kennedy King College, one of the city's colleges, currently located at 68th and Wentworth, into the area, thus creating a new type of neighborhood. This plan is not without its problems, mainly because it strips the community of its central shopping district, displacing the existing businesses. While some of the current retailers will stay in the area, many will move to other locations or shut down all-together. However, Kennedy King College will house a performing arts center and a culinary school. Dynamic, and sometimes controversial, Englewood has always been a vibrant neighborhood that possesses a strong sense of community imparted from its residents. Given this history and the current changes in the city, Englewood will continue to make its mark on the city's landscape.*

Over the years, and particularly since the 1970s, a few businesses and organizations have proven their staying power, including the Chicago City Bank & Trust, now Pullman Bank and Trust, Norman Jewelers, and the Englewood Business Men's Association. These entities have committed their resources to the neighborhood and work hard to keep up the community spirit.

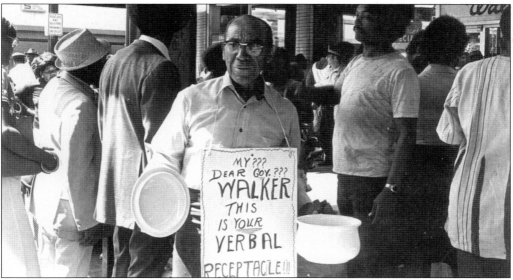

PROTEST, C. 1975. Richard Stamz and Reverend Jesse Jackson, among others, protest Gov. Dan Walker and Walgreen's in front of the Englewood Walgreen's store. Residents would often protest against state and federal programs that went against the needs of the community. Businesses were not immune from these protests, and individuals would voice their issues and concerns locally. (Photo courtesy of Richard Stamz.)

COMMUNITY GATHERING. Men pictured left to right, are State's Attorney Bernard Carey, State Rep. James C. Taylor, who later became a state senator, and Norman Kernis, seated. (Photo courtesy of Mrs. Frances Kernis and son, Mr. Jeffery Kernis.)

MERCHANTS AND RESIDENTS, ART FAIR, C. 1972. The Englewood Art Fair started in 1969 and continued until 1980. Merchants were asked to participate by donating services and taking part in the organization of the fair. Community business owners and residents are pictured displaying the annual poster for 1972. From left to right are: Bob Weber, Chicago City Bank & Trust; Norman Kernis; Harold S. Paddors, Three Sisters store; Doug Williams; Mort Krakow, co-owner of the Circle Inland Furniture Store; and Mr. Judge Barber, one of the first African American's to own a store in Englewood. (Photo courtesy of Mrs. Frances Kernis and son, Mr. Jeffery Kernis.)

ENGLEWOOD CITIZEN'S EVALUATION COMMITTEE FLYER, C. 1962. This committee cited individuals who made contributions to the community. Willie L. Pittman founded the annual Back to School parade, an event that has come to symbolize Englewood. Pittman focused his effort on youth-based initiatives. This announcement lists most of his achievements during the 1960s. (Photo courtesy of Richard Stamz.)

Englewood Citizen's Evaluation Committee

Don't Just Do Something - Stand There!
6503 S. LAFLIN STREET · CHICAGO, ILL. 60636

What have you done to make Englewood a better place in which to live?
I have made the following contributions to the Englewood Community...

*Organized the first Englewood-Back-To-School Parade in 1961, and has been Planner, Organizer, of each of the Back-To-School-Parades since that date.
*President and organizer of Central Englewood Youth Service, 1960-1965.
*Chairman of Youth Division of Englewood Community Organization, 1961-1966.
*Organizer and founder of the first Englewood Drum and Bugle Corps: Englewood Falcons.
*One of the organizers of the Green Street Association Block Clubs; also helped organize other block clubs in the Englewood Community.
*Active member of the Advisory Committee of the Englewood Urban Progress Center.
*Chairman of Our Lady of Solace School, Board in Englewood.
*Member of the Advisory Board of the Englewood Mental Health Center.

*Led the group of community residents who fought to have a voice in redevelopment of Englewood.
*Member of the planning committee of the Englewood Police Community Workshop.
*Recieved seperate awards from Illinois Youth Commission, Englewood AD H66 Agencies, and Englewood Bulletin for outstanding civic work.
*Supported and fought for the acquiring of a local medical center for the Englewood Community.

*Vice President of the Englewood Economic Development Corp.

*Worked on the planning committee that brought Dr. Martin Luther King Jr. into the Englewood Community to help the Green Street Association.

*Worked with the Veneral Disease Prevention Division of Chicago Board of Health in conducting health education programs in Englewood.

Helped in the Englewood program for Youth and assisted the Urban League in referrals for Youth training programs.

*Conducted seminars and discussion groups on Negro History at the South-Town YMCA for Youths and adults.
*Chairman of Al Trougott Scholarship Fund located in Englewood.

NAME____Willie L. Pittman____ADDRESS____6530 South Green Street

I REPRESENT_____

BACK TO SCHOOL PARADE, 1977. In this photo the parade heads north on Halsted Street. (Photo courtesy of Mrs. Frances Kernis and son, Mr. Jeffery Kernis.)

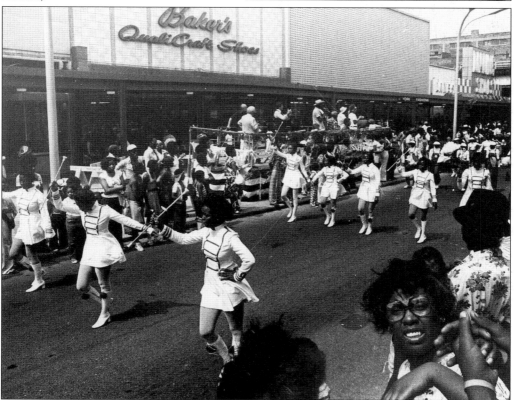

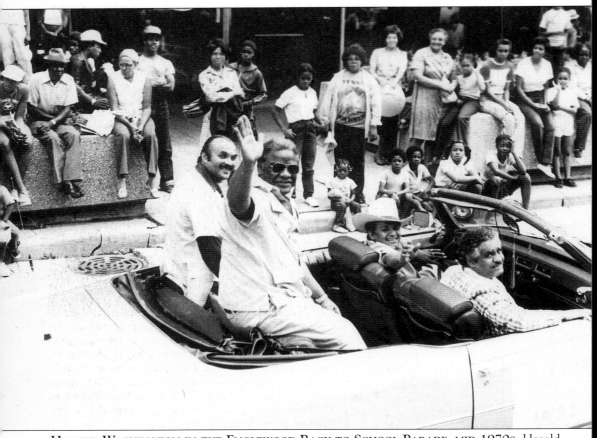

HAROLD WASHINGTON IN THE ENGLEWOOD BACK TO SCHOOL PARADE, MID-1970S. Harold Washington, state senator at the time, takes part in this annual tradition. Washington had an office in the Englewood Commercial District, corner of 63rd and Peoria. In 1980, he became a member of Congress in the U.S. House of Representatives. Washington went on to become the first African-American mayor of Chicago in 1983. In a highly controversial campaign, he beat Republican candidate Bernard Epton. Race played an issue in the campaign, however, Washington's leadership changed the face of politics in Chicago. (Photo courtesy of Mrs. Frances Kernis and son, Mr. Jeffery Kernis.)

CUSTOMER SERVICE AWARD, 1973. The Englewood Business Men's Association handed out awards to businesses in the commercial district. The group continued to encourage good business practices with the retailers in the area. Pictured here, from left to right, are Audrey Drew, EBMA, L. Fish Furniture employee Carrie Burwell, and Japanese-retailer Kiyoshi Takehara, owner of Keos Jewelry. To highlight this diversity, in the mid- to-late-1970s, many Koreans started opening businesses in the area and in the 1980s, started purchasing land for their companies and stores. Englewood's Korean merchants have contributed a great deal to the community. (Photo courtesy of the Englewood Business Men's Association.)

ENGLEWOOD CENTRAL CONCOURSE COMMISSION. Pictured from left to right are Ann Fredd, Norman Kernis, and Earl L. Neal. Neal provided legal counsel for the Englewood Central Concourse Commission during the 1960s and 70s. Norman Kernis was chairman of the commission.

Neal heads a respected law firm that has contributed greatly to Chicago neighborhoods, including Englewood. This minority-owned law firm was established in 1938 by Judge Earl J. Neal. Generations of the Neal family continue to thrive in this family business. Ann Fredd is an associate of Neal's and works with the firm. (Photo courtesy of Mrs. Frances Kernis and son, Mr. Jeffery Kernis.)

WIEBOLDT'S DEPARTMENT STORE, C. 1975. As time progressed, the Wieboldt's stores saw a general decline in their bottom-line and faced financial hardship. This building was demolished in the 1980s. The land was later acquired by Pullman Bank and Trust to further bank facilities. (Photo courtesy of Mrs. Frances Kernis and son, Mr. Jeffery Kernis.)

SNOW STORM OF 1979. This view shows the rear of the Chicago City Bank, looking north, near 63rd and Halsted. In early 1979, Chicago was struck with a major snow storm that essentially shut down the city. The city was ill-prepared to deal with the massive amount of snow. Democratic candidate Jayne Byrne used the storm against then-Mayor Michael Bilandic in the heated democratic primary. Bilandic lost his re-election bid to Jayne Byrne. (Photo courtesy of the Englewood Business Men's Association.)

MAYOR JAYNE BYRNE, GROUND-BREAKING CEREMONY, AUGUST 1979. After Sears Roebuck and Co. closed, the Phoenix Group, an African American-owned land development company built a strip mall on the site, located on the northeast corner of Halsted and 63rd Streets. Byrne became the first female mayor in 1979, but lost in 1983 to Harold Washington. Norman Kernis is pictured to the right of Mayor Byrne. (Photo by Mr. Pat, courtesy of Mrs. Frances Kernis and son, Mr. Jeffery Kernis.)

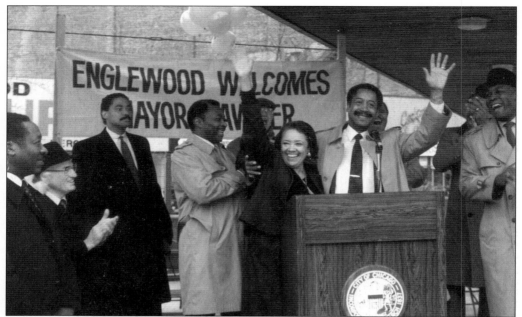

MAYOR EUGENE SAWYER AND ALDERMAN ANNA LANGFORD, C. 1988. Sawyer, mayor after the death of Harold Washington, visits Englewood. Sawyer was in office at the time the shopping center's mall was converted back to its original form, allowing cars to once again drive down Halsted. Many residents deemed this change essential because Ill. R-47, the plan that installed the mall, had failed to increase consumer and business traffic. This change was to the community's liking. Anna Langford was a proponent of the change, and as an activist, she worked hard on the community's behalf. (Photo courtesy of the Englewood Business Men's Association.)

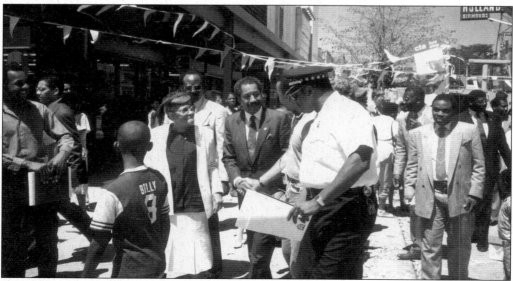

EUGENE SAWYER, 1988. Sawyer walks with Englewood residents. To the left of Sawyer is Ada S. Niles, who was instrumental in opening the Ada S. Niles Senior Center located on Halsted Street in Englewood. (Photo courtesy of the Englewood Business Men's Association.)

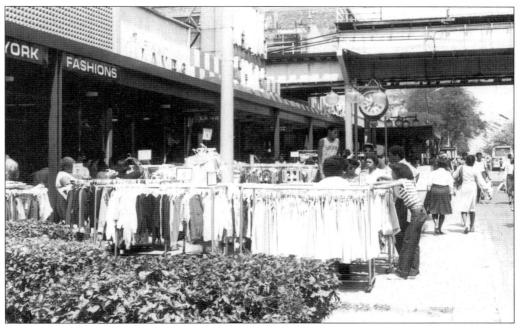

SIDEWALK SALE, C. 1985. Sidewalk sales became important events for retailers and shoppers in the Englewood Shopping District. These annual events, starting in the late 1960s, would draw so many people that it became difficult to move down the street. Merchants would organize and scheduled entertainment and radio personalities would emcee the events. (Photo courtesy of Mrs. Frances Kernis and son, Mr. Jeffery Kernis.)

SIDEWALK SALE, MID-1980s. (Photo courtesy of the Englewood Business Men's Association.)

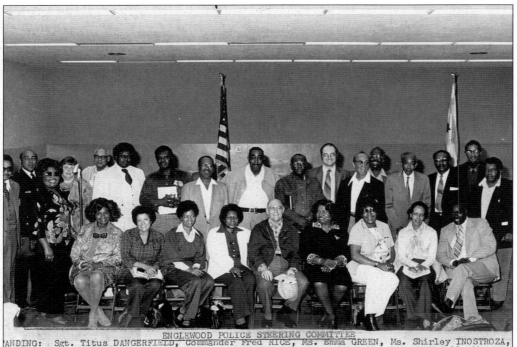

ENGLEWOOD POLICE STEERING COMMITTEE
'ANDING: Sgt. Titus DANGERFIELD, Commander Fred RICE, Ms. Emma GREEN, Ms. Shirley INOSTROZA,
 Mr. James STAMPLEY, Rev. Wilbur GARRETT, Mr. Alvin LONG, Mr. Lester McCALL, Mr.
 Brazil DENT, Mr. Darryl WAHLER, Mr. Richard STAMZ (Co-Chairman), Mr. Edward THOMAS,
 Rev. G. W. VANN, Mr. Abie EASTMAN, Mr. Fred JACKSON.
ATED: Ms. E. Thee Gladys MAXWELL, Ms. Anna LANGFORD, Ms. Bernita BRYANT, Ms. Ida STERLING,
 Mr. Eugene CONNOLLY, Ms. Mollie EDMONDS, Ms. E. HAWKINS, Ms. Linda JOHNSON,
 Mr. Willie PITTMAN.

ENGLEWOOD POLICE STEERING COMMITTEE. The steering committee was and is an important group of civic and community leaders that takes part in the safety of the neighborhood. Some noted individuals include James Stampley, Englewood historian and author of *Challenges and Changes: A Documentary of Englewood* (1979); Anna Langford, former Alderman and activist; Richard Stamz, co-author of this book; and Willie Pittman, originator of the Back-to-School Parade. (Photo courtesy of Richard Stamz.)

ART THOMPSON, 7TH DISTRICT POLICE STATION, AND RICHARD STAMZ, C. 1985. Through the 1980s and 1990s, Richard Stamz has participated in some auxiliary capacity with the police department. (Photo courtesy of Richard Stamz.)

INVITATION TO "AN ENGLEWOOD COMMUNITY SALUTE" HONORING POLICE SUPERINTENDENT FRED RICE, 1983. Rice is a well-liked and cherished member of the Englewood community. Long-time friend of Stamz, Rice has seen the neighborhood through many changes. This salute to his work indicates his prominent place in Englewood's history. (Photo courtesy of Richard Stamz.)

RICHARD STAMZ AND FRED RICE, 1983. Willie Pittman, founder of the Back-to-School Parade, is pictured in the background with his back to the viewer. (Photo courtesy of Richard Stamz.)

JAMMIN' IN THE MALL, C. 1985. In the 1980s and 1990s, the Englewood Mall Merchants sponsored and promoted community activities, much like they had in the past. Jammin' in the Mall was an annual summer activity, sponsored by the area merchants and the Englewood Business Men's Association. During the summers, bands were scheduled to play every Saturday during the season. The year 2000 was the last year the series was scheduled. (Photo courtesy of the Englewood Business Men's Association.)

JAMMIN' IN THE MALL, C. 1985. Jeffery Kernis, who took over the management of Norman Jewelers after his father passed away, is pictured on the right next to Thomas Weathers, who was the chairman of the promotion committee for the Englewood Business Men's Association. Audrey Drew is pictured with her back to the camera. (Photo courtesy of the Englewood Business Men's Association.)

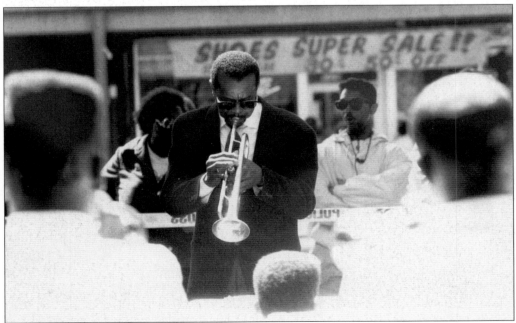

JAMMIN IN THE MALL, C. 1985. Pictured here is one of the musical entertainers that performed at the annual summer event. (Photo courtesy of the Englewood Business Men's Association.)

"IMAGINE ENGLEWOOD IF..." ORGANIZATION, 2001. This organization was formed to work toward improving Englewood socially and politically. Its major goal is to confront substantial community issues by interviewing individuals and businesses on neighborhood concerns. (Photo courtesy of Richard Stamz.)

"MAKE A DIFFERENCE" PROGRAM SERIES, C. 2000. Many organizations in Englewood take on the task of scheduling dynamic programs and performances that involve many layers of the community. (Photo courtesy of Richard Stamz.)

TWO-FLAT, HOME OF RICHARD STAMZ, c. 1985. Stamz has been a resident in Englewood since WWII when he bought this home. Much of the older housing stock was built prior to 1930. Many residents keep up improvements to their historic homes, despite the deterioration the area has experienced since the 1960s. The deed to Stamz's home includes a restrictive covenant, an agreement that limited the sale of homes to African Americans and other racially marginalized groups. This practice was used primarily in neighborhoods that surrounded black communities. African Americans who bought homes with these covenants sometimes faced eviction or legal action. Some fought back, and in 1948, the Supreme Court ruled that restrictive covenants were unconstitutional. (Photo courtesy of Richard Stamz.)

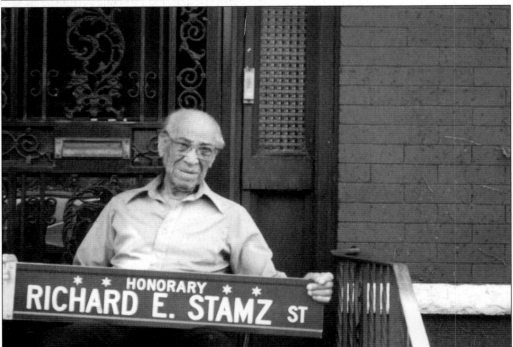

RICHARD STAMZ, 1999. Stamz received an honorary street sign named after him. It is located on Racine between 59th and 61st Streets. Stamz's pioneering work in radio and his activism in Englewood show his commitment to the City of Chicago. (Photo courtesy of Richard Stamz.)

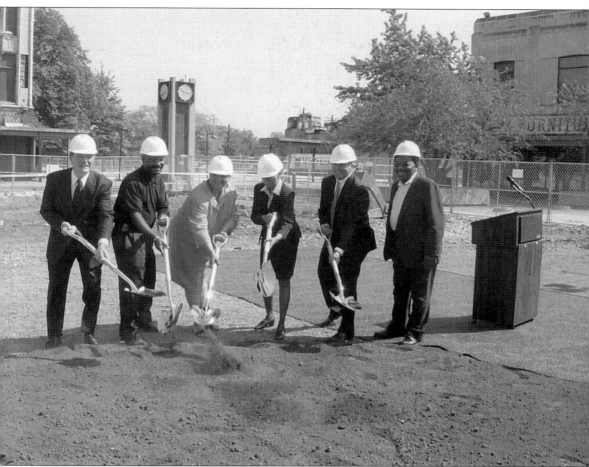

GROUNDBREAKING CEREMONY, PULLMAN BANK AND TRUST, 2002. Pullman Bank continues to grow and is currently building a new banking drive-in facility at its location on 63rd Street. Although the rest of the historic shopping district will be demolished to make way for Kennedy King College, Pullman will stay as a tribute to the past. Pictured from left to right are the following: Gavin Weir Sr., former president of Chicago City Bank & Trust and currently senior consultant at Pullman Bank and Trust; Reverend Jacques Conway, greater Englewood United Methodist Church; Alderman Shirley Coleman, 16th Ward Democratic Organization; Judy Jackson, assistant commissioner for planning and development; Daniel G. Watts, president and CEO of Pullman Bank and Trust; and Henry Wilson, chairman of the Englewood Conservation Community Council. (Photo courtesy of Pullman Bank and Trust.)

SELECTED BIBLIOGRAPHY

Cronon, William (1991). *Nature's Metropolis: Chicago and the Great West*. W.W. Norton & Company: New York.

Duis, Perry, R. (1998). *Challenging Chicago: Coping with Everyday Life, 1937–1920*. University of Illinois Press: Chicago.

Franke, David (1975). *The Torture Doctor*. Hawthorn Books: New York.

Gray, Mary Lackritz (2001). *A Guide to Chicago's Murals*. The University of Chicago Press: Chicago.

Gude, Olivia & Huebner, Jeff (2000). *Urban Art Chicago*. Ivan R. Dee: Chicago.

Harris, Neil, de Wit, Wim, Gilbert, James, & Rydell Robert W. (1993). *Grand Illusions: Chicago World's Fair of 1893*. Chicago Historical Society: Chicago.

Holli, Melvin G. & Jones, Peter d'A. (Eds.) (1995) *Ethnic Chicago: A Multicultural Portrait*, 4th Edition. William B. Eerdmans Publishing Company: Grand Rapids, MI.

Miller, Mark Crispin (Ed.). (1990). *Seeing Through Movies*. Pantheon Books: New York.

Pacyga, Dominic, A. & Skerrett, Ellen (1986). *Chicago: City of Neighborhoods: Histories and Tours*. Loyola University Press: Chicago.

Sinkevitch, Alice (Ed.). (1993). *AIA Guide to Chicago*, (compiled by the American Institute of Architects Chicago, Chicago architecture Foundation, and Landmarks Preservation council of Illinois). Harcourt Brace & Company: New York.

Stampley, James, O. (1979). *Challenges with Changes: A Documentary of Englewood*. Chicago: USA.

Sullivan, Gerald E. (1924). *The Story of Englewood, 1835–1923*. (Written and compiled under the auspices of the Englewood Business Men's Association.) Foster & McDonnell: Chicago.